HOW TO LOOK AT EVERYTHING

How to

Look at

Everything

BY DAVID FINN

HARRY N. ABRAMS, INC., PUBLISHERS

Editor: Elaine M. Stainton
Designer: Dirk Luykx

Library of Congress Cataloging-in-Publication Data

Finn, David, 1921–
How to look at everything / by David Finn.
p. cm.
Includes index.
ISBN 0–8109–2726–8 (pbk.)
1. Photography—Philosophy. 2. Visual perception.
3. Photography—Psychological aspects. I. Title.
TR183.F55 2000
700'.1'1—dc21 99–41257

Excerpt from *The People, Yes* by Carl Sandburg, copyright 1936 by Harcourt, Inc., and
renewed 1964 by Carl Sandburg, reprinted by permission of the publisher.

Excerpt from *The Waves* by Virginia Woolf, copyright 1931 by Harcourt, Inc., and renewed
1959 by Leonard Woolf, reprinted by permission of the publisher.

Printed and bound in Japan

Harry N. Abrams, Inc.
100 Fifth Avenue
New York, N.Y. 10011
www.abramsbooks.com

CONTENTS

CHAPTER ONE

The
Mind's
Eye

THE WORD *EVERYTHING* IN THE TITLE OF THIS BOOK
may seem too all-encompassing, but I have in mind the incredible range
of things we can *see* when our mind pays attention to the images trans-
mitted by our eyes. *Everything* includes the stars in the sky, the branch-
es on a tree, a matchbox cover. It includes anything we may see at any
time in any place. Our subject, however, is not *what* we look at, but
how we can open our minds and hearts to see more than the literal
image and be inspired by the vision that takes place in our minds. As
the painter Agnes Martin put it, "when your eyes are open you see
beauty in anything."

Think of looking at the sky on a clear night and seeing the pin-
points of light against a dark background. Speculating about those stars
is one of the most provocative experiences known to mankind.
Ancient cultures built entire beliefs about time, eternity, and the mean-
ing of existence around the movement of the stars. The Egyptian
astronomer Ptolemy once wrote that when he followed the movement
of the stars he felt that his feet no longer touched the earth. He found
himself in the company of Zeus, feasting on the food of the gods.

Many different images of the universe have formed in the minds of people gazing at the stars. For example, in Adrienne Rich's poem, "For the Conjunction of Two Planets," she wrote:

We smile at astrological hopes
And leave the sky to expert men
Who do not reckon horoscopes
But painfully extend their ken
In mathematical debate
With slide and photographic plate.

And yet, protest it if we will,
Some corner of the mind retains
The medieval man, who still
Keeps watch upon those starry skeins
And drives us out of doors at night
To gaze at anagrams of light.

Whatever register or law
Is drawn in digits for these two,
Venus and Jupiter keep their awe,
Wardens of brilliance, as they do
Their dual circuit of the west –
The brightest planet and her guest.

Is any light so proudly thrust
From darkness on our lifted faces
A sign of something we can trust,
Or is it that in starry places
We see the things we long to see
In fiery iconography?

When we read of new discoveries made by astronomers, looking at the stars can give us a sense of the incomprehensible vastness of the universe (or universes). We somehow feel in touch through our eyes with an ultimate reality that we do not understand and probably will never know.

We may have a similar feeling when we pick up a pebble that

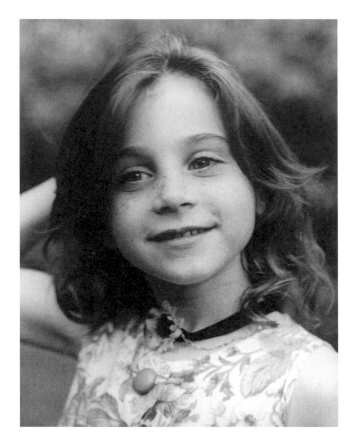

The photographer's granddaughter, Rebecca

attracts our eye on a dirt road and wonder how it got there; we hold it in the palm of our hand as if it were a precious stone, and perhaps keep it as a memento. Cars in a busy street can make us think about the quality of our lives as we move faster and faster from place to place. The look and behavior of "dumb" animals create a sense of kinship that belies an assumption of their ignorance and lack of feeling. The face of a beautiful child—or the faces of a mother and child—radiate qualities that ennoble us all. I have taken photographs of my grandchildren every year since they were born; at the time of this writing the oldest is twenty-six years old, and the youngest is eleven, so I have accumulated a lot of photographs! I never tire of looking at the faces of youngsters; they are all beautiful.

One of the most moving photographs of a child I have ever seen was taken by William Boorstein in the central highlands of Irion Jaya, Indonesia, the western half of the island of New Guinea. "I met this Yali woman and child," Boorstein wrote, "as I was walking along a mountain trail above the village of Membahan. (Yali is the name of the tribal group.) The beads were gifts from western missionaries." The detail of the face of the child against the mother's breast is extraordinary. One can almost feel the intimacy and sense of protection experienced by the child and the pride and joy of the mother, even though one cannot see her face.

There are times when a random sight turns out to have significance for us in ways that are hard to describe. When the photographer Marilyn Ellner accompanied a group of New York City students to China on a trip organized by the American Forum for Global Education, one of her favorite shots was of a young child playing peek-a-boo with her from behind some intricately carved stonework. Somehow, in revealing through her camera lens the accident of that momentary eye contact with the Chinese child, the American photographer brilliantly expressed the universality of human experience in her affecting image.

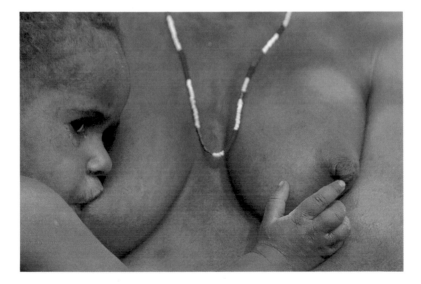

Yali #2 (mother and child in New Guinea). Photograph by William Boorstein

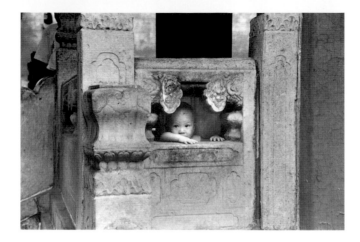

Peek-a-boo (child in China). Photograph by Marilyn Ellner © 1998. All rights reserved

Association plays a key role in what the mind's eye sees. Thus, when we look at homeless people in the streets we may be reminded of the images of suffering created by Donatello, Goya, and Rembrandt, or seen through the camera lens of Jacob Riis, Dorothea Lange, and Louis Hine. These associations may cause us to feel particular sorrow for the fate of fellow humans who are living in such appalling conditions.

The mind's eye incorporates what we know with what we see. Since each of us has a unique conglomeration of facts, memories, associations, and speculations in our heads, what one mind's eye sees at any moment is very different from what another mind's eye sees. Artists, writers, and personal friends can open our eyes to what they see and thereby enlarge our vision, but ultimately the images that form in our brains are our own.

Sometimes we even invent what we see. "Those images that yet/Fresh images beget" wrote the poet Yeats. The images in our mind are the product of an active imagination that continuously creates new "realities." Some years ago there was a plan to create a monumental, five-hundred-foot-high figure of the revered Sioux hero, Chief Crazy Horse, commemorating the achievements of this great leader by carving the largest mountain sculpture in the world in the Black Hills of South Dakota. If I recall correctly, some members of the tribe objected to the project on the grounds that they did not need to carve up a whole mountain to remember him. By looking at a beautiful sunset, watching a bird fly, or looking at a cloud drifting by they could remember the spirit of Crazy Horse. That was their way of *seeing* the image of their revered ancestor.

There is an inner eye that creates the mind's image for what the senses sense. In some religious traditions this inner eye has been described as the soul itself. Hindus have sometimes called the soul "the seer" or "the knower," believing that it was like a great eye in the center of one's being through which one could see "reality."

That inner eye not only "sees" but hears as well. Music, which reaches us through our sense of hearing, enables us to see an aspect of the world we cannot see with our eyes. The German poet Heinrich Heine once wrote that music was a miracle halfway between spirit and matter, a sort of nebulous mediator that was both like and unlike the things it mediates.

People who are denied the use of their senses sometimes "see" with greater sharpness than others do. Homer and Milton, both blind, visualized their worlds of imagination with unsurpassed vividness. The incredible Helen Keller, who was blind, deaf, and mute, once put her fingers on the lips of a rabbi while he was uttering a prayer after a meal, and said (by communicating to the palm of her companion's hand) that she had just "heard the voice of God."

Helen Keller's hands were clearly sensitized beyond anything most of us can imagine. But if we look at our hands with a fresh eye, we can have a glimpse of what hidden resources they may contain. Holding them up to the light brings to mind the subtleties of the sense of touch that many of us too often take for granted. The gesture of thrusting one's hands into the air in itself suggests embracing the world around us. A sculpture by the twentieth-century sculptor Gaston Lachaise shows a woman's hands thrust into the air as a way of expressing pride in her being. Another sculpture with a similar pose, on the grounds of the headquarters of the International Olympic Committee in Lausanne, expresses the ideal of reaching ever-new heights of human achievement.

The striving for excellence on the part of champion athletes was a favorite subject for the artists of ancient Greece. One of the treasures of the archaeological museum in Athens is "The Jockey," a small boy riding his great horse. The position of the figure's arms and legs, the determined look on the face, the garments flowing in the wind, all communicate a powerful sense of movement caught in an instant of time. Today we watch the performance of world-class ice skaters, skiers, gymnasts, and those engaged in competitive-sports, in awe as they

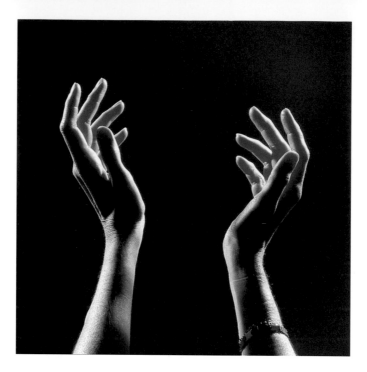

Hands held up to the light

show us their strength, grace, and versatility. The art of ballet reveals the beauty of male and female figures as they move their limbs to expressive musical passages, enabling the sensitive eye to see the movement of the human body as one of nature's masterpieces.

The interplay of the arms and legs of dancers is echoed in a variety of man-made structures, which we sometimes find in unexpected places and from unusual vantage points. I once visited the sculptor Eduardo Chillida in his home in San Sebastian, Spain, and on a large stretch of rolling land called Zabalaga, owned by the sculptor's foundation and where many of his works are sited, I saw an old barn that he had restored. Inside, there were wonderful beams holding the structure together, and in one corner I was fascinated by mighty wooden arms reaching out to support the roof. In another anthropomorphic play, at the edge of the sea below Chillida's home, he had created great metal forms that resembled clutching fingers reaching out from the rocks into the sky. Chillida calls the sculpture *The Comb of the Wind*.

One of the secrets of the art of looking is the ability to focus on details. That is not very different from shopping in a store where your eye picks out from a multitude of objects those that happen to interest

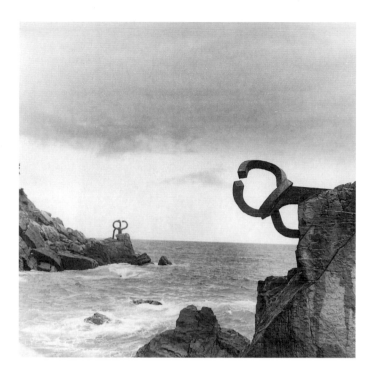

The Comb of the Wind by Eduardo Chillida

you. The trick is to know what you are looking for. In a supermarket, you may be trying to find a particular brand, or size of container, or item on sale; if you are a practiced shopper you will know how to find what you seek. You also may be able to pick out a sought-after book in a wall of bookshelves because you remember something about the jacket.

Much the same process takes place when your eye is glancing around you wherever you are, and looking for something that may be esthetically moving. Even the smallest and most common object can make a profound impression. "I can look at a knot of wood," William Blake once told a friend, "till I am frightened by it." The photographer Paul Strand once said, "What I have explored all my life is the world at my doorstep . . . The things that come close to me today are those literally only a few feet away in our garden."

By looking carefully at things that excite us we can train our eyes to see what others may not notice. My wife, Laura, loves jewelry created by the Italian designer Mario Buccellati, and whenever we visit one of his stores she can spend literally hours looking at the intricate workmanship of pins, rings, and bracelets. Sometimes we have pur-

chased precious stones on our travels to Japan, India, or South America and brought them to our friend Elena Morandi, who has run the Florence Buccellati store for many years and who helps design pieces of jewelry in which our stones can be set. I think sharing this creative endeavor has sharpened my eyes, and Laura's, too, to the artistry of minute metalworking. It has also enhanced our appreciation of jewelry and other works of art that we find in museums. Similarly, the lifelong friendship that we have enjoyed with a master carpenter, Anthony Ricevuto, and the sensitivity to his superb craftsmanship that this friendship has fostered, has made us admirers of fine woodworking whenever we come across it.

Among the best teachers I have had to sharpen my eyes are trees. I love the delicacy of branches so beautifully portrayed in Chinese paintings through the centuries. I have long marveled at the quick brushstrokes of those paintings, which capture the graceful twists and turns of arboreal growth. I have also learned a good deal from the paintings of Corot, who seems to have had a unique ability to depict trees as they rise up from the ground and branch out with such remarkable grace. Our family had a tree in our garden that we especially treasured. It was a Japanese apple tree, and our children and grandchildren always loved to climb as high as they could and sit on various perches. In the spring bright red blossoms bloomed for a few days as a herald of the new season. In the summer it spread out its leaves to create a canopy to protect us from the heat. In the fall, it was one of the last trees to shed its leaves, and it retained its autumn colors almost to the end. In winter, its twisting branches cast a symphony of shadows on the snow. We called it "the marrying tree" since all our children were married under it. It was one of our most precious possessions. I once painted a portrait of that much-loved tree as part of a series inspired by Keats's *Endymion*; it seemed a perfect image to accompany the lines, "An endless fountain of immortal drink/Pouring unto us from the heaven's brink." The tree seemed filled with an infinity of visual delights. In time we found that the leaves were thinning out, and we worried that it was getting old. We fed it in the hope of extending its life and periodically cut off branches in the hope that it would give new strength to the rest of the limbs. But eventually we lost the battle and the tree died. We were heartbroken.

When we called a tree man to cut our tree down, I thought I saw

the forms of a dancer in the branches that were left. Although I had looked at that tree a thousand times, I had never *seen* those before. I asked the tree man to leave the trunk and those few branches for me to contemplate. Then I had the idea of carving the dancer out of the tree. It took me several years to do so, and I had to work around many parts of the wood that had decayed, but finally I succeeded. Our marrying tree now lives on as a life-sized dancer mounted in my office where I can enjoy its re-creation, and relive the many visual pleasures it has given me over the years.

As I have grown older, I have found more and more to admire in trees. I think they create some of the most wonderful living forms one can find anywhere. So fascinated am I by their qualities that I have made it a ritual to paint a watercolor of a tree every weekend for a number of years. I always find something new to excite my eye and brush; painting that watercolor is my way of paying homage to the life force that produced those extraordinary forms. Each painting is like a prayer in which I celebrate the remarkable gracefulness of the sturdy trunks, the twisting and turning branches, and the changing foliage in spring, summer, and fall. I date those paintings as if they were my diary, a record of the experiences I have from week to week that enrich my life.

What is it that goes on in our brains that transforms commonplace sights into images that can have this kind of effect? Perhaps some neurological discovery will be made one day that will explain how it happens. People who know how to meditate deeply have described the sense of awareness of the outer world and the feeling of oneness with the universe that accompanies the state of ecstasy they achieve. Others have testified to the sharpness of vision that is induced by certain drugs. But great artists may have developed their own sight-enhancing practices. They know how to trigger the nerve-endings in their brain that make *seeing* more than just *looking*. The artist Henri Matisse used to tell his students that the inner feeling they had when looking at something was more important than what they saw literally with their eyes. What was important was to "render the emotion" awakened within them. He urged them to close their eyes and hold the vision, and they would see the object better than with their eyes open. In his essay "Exactitude is not the Truth," Matisse wrote that conviction does not depend on "the exact copying of natural forms . . . but on the profound

Pin designed by
Mario
Buccellati,
Florence, Italy

feeling of the artist before the objects that he has chosen, on which his attention is focused and the spirit of which he has penetrated."

Matisse would have been fascinated by the strange case of Stephen Wiltshire, an autistic child who, at the age of twelve, appeared in a 1987 BBC documentary entitled "The Foolish Wise Ones." Although Stephen's verbal skills were negligible and he did not appear to relate to other people, he possessed an uncanny visual memory of scenes that he looked at for an instant and then could reproduce in a drawing with astonishing accuracy. In the aftermath of the excitement caused by the television program, Stephen was taken, under the auspices of several sponsors, on visits to New York, Paris, Venice, Amsterdam, Leningrad. The meticulous drawings he produced of those cities were published in a book entitled *Stephen Wiltshire, Floating Cities* (1991), and it included such startling images as a view of the Palace Square in Leningrad, drawn as if Stephen had seen it from high above. The eminent neurologist Oliver Sachs, who accompanied Stephen on his trip to Russia, wrote that the youth had "immense powers of perceiving detail, of spatial sense, of draughtsmanship, of memory," which was inexplicable in a child who would always be in need of special care. Despite the limitations in one part of his brain, the sharpness of his mind's eye was extraordinary.

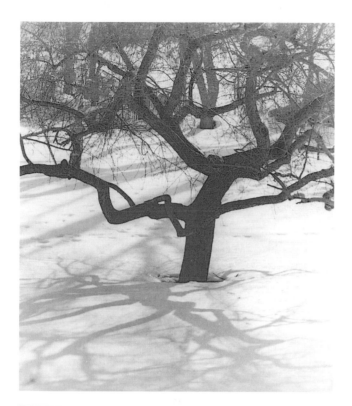

Japanese apple tree
in winter

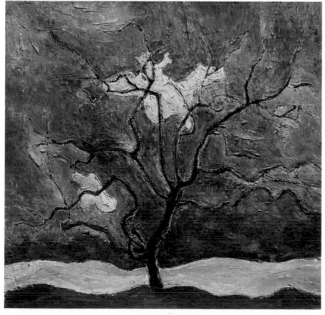

Oil painting of the
Japanese apple tree,
by David Finn

There appears to be something about *seeing* that reaches deep into the psyche and is quite apart from other mental faculties. Leonardo DaVinci called it "the best and the most noble" of our senses. He asked, "Do you not see how the eye embraces the beauty of the whole world?" Emerson once referred to himself as a "transparent eyeball," through which "the currents of the Universal being" circulated.

Novelists have often focused on the nature or mood or experience of their characters by describing the look in their eyes, or the way they look at others. When my grandson, Matthew Bloomgarden, was seventeen years old, he wrote a report on "The Eyes of Dostoyevsky." In the novelist's *Crime and Punishment,* Matthew observed that "Dostoyevsky reveals insights into the characters themselves, their emotions and their thoughts, when he describes details about eyes." Raskolnikov's eyes were described as "dry, feverish, piercing;" Sonia's as "tortured." Marmeladov's eyes "seemed to glitter with a kind of exultation—there was perhaps some understanding and intelligence in them, but at the same time there was also something that looked very much like madness." Raskolnikov thought that Lisaveta and Sonia had a way of gazing "at you with their meek and gentle eyes." Alyona Ivanovna had "two sharp and mistrustful eyes . . . something like a sneer in her eyes." Elsewhere there are references to "dreadful, stern, jeering eyes," and in another instance to "gentle blue eyes, which could flash with such fire, such strong emotion." Later, with Raskolnikov, "it was as though a flame had blazed up in his lusterless eyes. . . " Porfiry's face "would have been good humored but for the expression of his eyes, with a sort of faintly watery glint in them, covered with almost white, blinking eyelashes which conveyed the impression that he was constantly winking at someone."

Eyes are magical as communicators in what they reveal to others as well as what they can perceive for the viewer. In a major exhibition of the works of Modigliani at New York's Museum of Modern Art in 1995, I was especially moved by a charcoal self-portrait of the artist as a young man, an image that portrayed only his eyes. The idea of showing the artist's eyes alone was an original one. When I looked at those eyes I felt as if he had made a creative statement of remarkable significance. Just showing his eyes without the rest of his facial features seemed to me to reveal what *he* saw as he looked out into the world. I intuitively felt that what he saw with his eyes was more than what

most other people saw with their eyes. Modigliani's eyes suggested the power and working of a remarkable mind. I sensed a burning desire to search for the unknown, a fierce determination to create what no one else has ever seen before. As an original artist who had a tremendous impact on the twentieth century, his eyes were prophetic. His whole life was dedicated to his unique vision. His eyes were not only windows into his soul for us, but windows into the world for him.

It occurred to me that it might be generally true that when looking at artists' eyes in self-portraits, we can become conscious of something more than an insight into the personality of the subject. It is not just the revelation of the artists' character that we can find in their eyes, but a picture of eyes that have the power to look at everything with great concentration. We can imagine in their expression what it must be like to see the world around them with an extraordinarily penetrating eye.

The most uncanny experience I ever had looking into the eyes portrayed by an artist occurred when I was photographing a reliquary of San Rossore for a book on Donatello. The sculpture was in a chapel of the church of S. Stefano dei Cavalieri in Pisa. Fortunately, the sacristan permitted me to spend as much time as I wanted to photograph it from every angle. At one point, when I focused my camera for a close-up of the face, I gasped in astonishment. Looking through my viewfinder at the eyes of the sculpture, I had the feeling that I was looking into the soul of Donatello himself. The eyes of Donatello's sculptures of prophets and other religious figures had always intrigued me, for they seemed to be looking at some spiritual reality that ordinary mortals could not see. But somehow these eyes were different. I could not explain why, but the close-up view of the face mesmerized me, and it proved to be one of my favorite shots when it was subsequently published. Some years later I read an article in a scholarly publication by Anita F. Moskowitz, who suggested for the first time that the sculpture of San Rossore might in fact have been a self-portrait of Donatello, an unexpected corroboration of what I had felt when seeing it with my camera eye.

Subsequently, I had a different but related experience when I studied two self-portraits by Rembrandt in the National Gallery in London. One was painted when Rembrandt was thirty-four years old, in 1640. The stance of the figure is said to have been inspired by

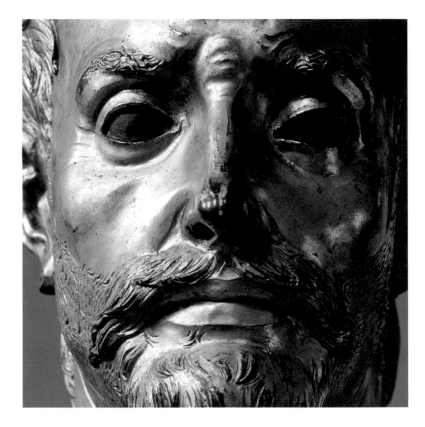

San Rossore
by Donatello,
S. Stefano dei
Cavalieri, Pisa

Titian's portrait of "A Man with a Blue Sleeve" in the National Gallery in London, which in the seventeenth century was thought to be a portrait of the famous Italian poet, Ludovico Ariosto. The painting had been sold at auction in Amsterdam in 1639, just a year before Rembrandt painted this self-portrait. By taking on the same pose as the Titian portrait, Rembrandt may have been trying to identify himself with Ariosto and thereby stake a claim for himself as a great artist.

The other self-portrait, which is in the same gallery, was painted some twenty-nine years later, in 1669, when Rembrandt was sixty-three years old. This was the year that he died, after having gone through a number of painful trials in the last years of his life, including personal bankruptcy and the death of his only son. The contrast in the

general appearance of the two self-portraits was remarkable. The early painting showed a proud and self-assured artist; the later painting showed a humble, self-denigrating elderly man without pretensions. And when I cupped my hands to focus attention on the eyes alone, I thought I saw something more. Unless it was my imagination, I was convinced that I saw in the eyes of the young man a sense of supreme self-confidence. No artistic challenge would be too daunting for him. He saw himself as a master at the height of his powers. The eyes in the other self-portrait were those of a man who had been humbled by life's experiences. Although only sixty-three years old, he thought of himself as an old man who had suffered painful hardships. His eyes seemed to say that he was long past the feeling of pride in his abilities or of being impressed with his fame. His eyes were weary, almost as if they had seen too much. He no longer looked forward to what life might bring to him in the future. Ironically, in portraying himself in that spirit he produced one of his supreme masterpieces.

Almost as compelling as Rembrandt's self-portraits is the famous self-portrait drawing by Leonardo DaVinci, now in the Royal Library in Turin, which has become something of an icon in the history of art. I wondered if the carefully drawn eyes show a man who feels sure of his analytical ability to reproduce in a precise way what he sees, or what his fertile mind invents. I could not seem to read as much in this drawing as I could in the Rembrandt painting. For one thing, Leonardo showed himself looking away from the viewer, and for another, the eyes did not seem as personal or revealing as Rembrandt's. Still, I thought I could sense the power of Leonardo's brain in those carefully delineated eyes.

Then I looked at many other images in books I have in my library and let my imagination roam. In Goya's self-portraits, did I not see a man who looked at the world with a highly critical eye, a satirical judgment on the follies of mankind, a bitterness about the evils brought about by human cruelty? In Van Gogh's self-portraits, did I not see the eyes of a man who was almost frightened by the beauty he saw in everything around him? I looked at the eyes in self-portraits by Ghiberti, Dürer, Michelangelo, El Greco, Ingres, Cézanne, Matisse, and Beckman. They all seemed to convey something distinctive.

These were, after all, the seers of the world!

By looking at their eyes in their self-portraits I thought I could not

only glimpse something of their inner selves but also have an idea of the special gift that enabled them to see—and portray for us—a unique vision of the world around them.

When I was in the National Gallery in London recently, I spent some time, as I always try to do, in front of Van Eyck's portrait of Giovanni Arnolfini and his wife, a favorite of mine since childhood. With his visionary eyes, Van Eyck was able to depict details I never tire of looking at. I was amazed once again by the reflections in the concave mirror (including the reflection of the artist himself, painting the picture) the texture of the wooden sandals lying randomly on the floor and the slippers further back in the room, the glistening metal of chandeliers, the brilliance of small glass panels in a half-opened window, the folds of fine cloth and the fur of the garments, and the dog wagging his tail in the foreground. There are so many details that I could go on for pages describing them. I also marveled at the expressions on the faces, the grandeur of the gestures, the perfectly harmonized composition, and the colors of the painting. All this is what Van Eyck's amazingly sharp eyes saw in the scene in front of him.

Artists open our eyes to the world in different ways. Once we have seen Van Gogh's paintings of sunflowers, wheat fields, and cypresses, we may forevermore see those things as he saw them. And the same is true of later artists who have their own way of forcing us to look at commonplace objects in new ways. With Duchamps's "Urinal," for instance, we look at an ordinary piece of plumbing equipment as a work of sculpture because he took it out of its usual setting in a men's restroom and mounted it on a pedestal as a work of art. The same happens to us when we see Lichtenstein's comic strip paintings. They look almost identical to the real thing, but he has seen them in a way that opens our eyes to a new way of looking at these commonplace images—with his clean, sharp lines, with dots and other patterns covering large areas, with bright colors, all carefully composed and painted as if the subject was a vivid landscape. We may make similar discoveries with Christo's umbrellas, running fences, and wrapped buildings, or Oldenberg's giant shuttlecock, eraser, electric plug, and clothespin. All these are objects that we are so used to seeing that we may not bother to look at them with a sensitive eye until an artist jars our senses and shows us what we have been missing.

Many people make such discoveries in different ways. My wife

and I for years have spent Saturday mornings going to what are called in our part of the country "tag sales," sometimes called "estate sales." These are held in private homes near where we live, in New York's Westchester County. Couples may have retired and moved south, or they may have bought a new house, or they may have died. Everything not wanted by the family is up for sale, and this can include hundreds of objects ranging from furniture, to works of art, clothing, jewelry, books, and often an amazing variety of objects that have been collected over the years. When we started our Saturday morning adventures, I felt as if we were invading people's private lives, or scavenging among things we wanted to buy that might have been precious to the previous owners for personal reasons. But my wife has persuaded me that the people who orig-

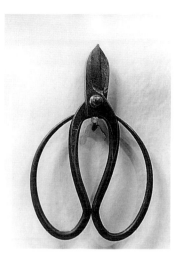

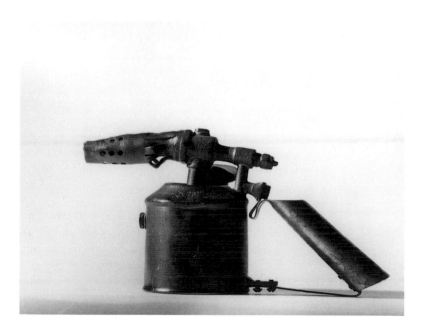

Above and left: Objects bought at tag sales: pair of scissors; miner's gas light

Oarlock from
a gondola,
Venice

inally owned these objects might well like the idea that others who love
the things they owned have now acquired them for their families.

What often amazes me in those tag sales is seeing what people
have kept in their homes as mementos, often things of no special mon-
etary value, but which obviously meant something special to the own-
ers. Among the objects I have picked up at these tag sales are an ancient
plane that is still sharp, a beautifully shaped scissors, a brass spigot, an
African stool, and a miner's gas light. I always feel that I can see some-
thing in those objects that is especially meaningful, although often I
can't explain why.

In the course of my travels, many ordinary objects have caught my
eye in the same way, and I have made a habit of making them part of my
life. Once when I visited a cotton spinning plant owned by Springs
Industries in South Carolina, I was dazzled to see hundreds of spools

of cotton thread automatically rotated on holders as the cloth was made. Seeing several spools in a waste-bin, I took one to keep on my office desk. At another time, when I was visiting a steel plant in Johnstown, Pennsylvania, a group of curiously shaped steel objects were stacked on a shelf; the shapes were so striking to me I took one of them to keep as a work of art. In Venice I bought an oarlock for a gon-dola that looks like a sculpture by Jean Arp. At another time in Lima, Peru, I saw some men on the beach making a large canoe out of reeds, and I couldn't resist picking up one of the reeds that lay on the sand to add to my collection. When I was at a construction site in Bilbao, Spain, where the extraordinary new structure designed by Frank Gehry as the new Guggenheim Museum was being built, I found a wonderfully rusted and partially scarred rectangular section of a metal casing; it now sits on my mantelpiece as a treasured sculpture. In Alaska I found a broken piece of ivory that seemed to be part of a sled; the shape made by the accidental break makes the piece especially strik-ing for me. It now sits on a tabletop in my dining room. In Ghent, I found a half-dozen small weaving spindles and later tied them together with a string to make an appealing composition. In the Cotswolds I found an old lock mounted in a wooden frame with a rich patina on the metal casing.

I can't explain my attraction to these objects in traditional esthet-ic terms—pointing to a beautiful curve here, a striking composition there, a powerful statement about life. They are just objects that appealed to me at a particular moment, and some instinct within me made me want to keep them. The images in my mind were formed by associations of which I was at best only vaguely conscious, and the intersection of these buried experiences with the objects I saw made me want to keep them.

This is the instinct that has led me to become a collector: some-thing in me is touched by an object, and I am prompted to acquire it. There may or may not be a practical value in the object, but I know that just to have it around or in my possession adds something to my life. My wife, Laura, also has this instinct. She collects models of owls, and we have scores of them in our home. She would be hard put to explain why she loves them but her eyes light up when she finds a new one to add to her collection. I collect books, although I cannot explain why. I read as many as I can, but I could not possibly read the thousands of

books I have bought over the years. Partly, I know, I buy them because I would like to read them someday; but even if I cannot find the time to do so, having them around me gives me an inexplicable pleasure.

Once when I was in Kenneth Clark's home in Saltwood, England, I asked him about one shelf in his library that contained very large books. He pulled one of them out and was clearly thrilled to show it to me. He probably hadn't looked at that book for years; but he knew that it was there, and occasionally, perhaps, glanced at its spine, along with those of all the other books on that and other shelves and just felt the pleasure of having it in his possession. That is how I feel about the books in my library. When I see them on the shelf, whether I have read them or not, they are part of my life, and I feel blessed by their presence.

Perhaps the most fabulous collector I have known of miscellaneous objects is Nathan Ancell, the founder of Ethan Allen stores. Walking into his house in New Rochelle, New York, is an unforgettable experience. There is practically no room to stand in the house, let alone sit down. His tastes are broadly eclectic, ranging from Russian jewel boxes to a bewildering variety of canes, strange objects carved out of wood, models of all kinds, posters, bowls, sculptures, paintings—literally thousands of things. Most of them he has bought at antique shows, and he always has a great time negotiating with sellers to get a bargain price. There was never a plan in his head for what he would do with all these objects; just looking at something that fascinated him and deciding to add it to his collection gave him great joy. One time my wife and I admired a particularly lovely art nouveau sculpture on a shelf (along with dozens of others); Ancell picked it up and gave it to us. We have enjoyed displaying it in our dining room for years.

So how does one look at everything through the mind's eye? This book will attempt to give some guidance; but the shorthand answer is *with passion.* One can be passionate about anything one sees—*anything* and *everything.* All it takes is the willingness to open your eyes and your heart, and let feelings grow strong within you. What you look at could be a blade of grass, or a branch of a tree, or the shadow on a wall, or a fabulous diamond on display in a jewelry store. Or it could be a bed of flowers in the garden that evokes the past, as in Donald Hall's moving poem, "Weeds and Peonies" written after the death of his wife, the poet Jane Kenyon:

Your peonies burst out, white as snow squalls,
with red flecks at their shaggy centers,
in your border of prodigies by the porch.
I carry one magnanimous blossom inside
to float in a glass bowl, as you used to do.

Ordinary happiness, remembered in sorrow,
blows like snow into the abandoned garden
to overcome daisies. Your blue coat
disappears up-mountain into imagined snowflakes
with Gus at your side, his great tail swinging;

but you will not return, tired and satisfied,
and sorrow's repeated particles suffuse the day
like the dog yipping through the entire night,
or the cat stretching awake, then curling
to dreams of her mother's milky nipples.

A raccoon dislodges a geranium from its pot.
Flowers, roots, and dirt lie upended
on bricks you set in the back garden's patio
where lilies begin their daily excursions
above stone walls, in the season of old roses.

I pace beside the weeds and snowy peonies,
staring at blue Kearsarge five miles south.
"Hurry back. Be careful, climbing down."
Your peonies lean their vast heads westward
as if they might topple. Some topple.

The mind's eye is magical. Through it we can see loved ones who
are no longer here, by looking at objects they owned that were precious
to them. We can create works of art in our heads out of a special vision
that we can nurture within us. One way that we can nurture this
vision is by looking at art created by masters. These masterpieces can
teach us how to transform what we look at with our naked eye, or
what we imagine in our mind's eye. All we need is the will to do so.

CHAPTER TWO

The

Gift of

Light

"AND GOD SAID, LET THERE BE LIGHT: AND THERE WAS light. And God saw the light, that it was good and God divided the light from the darkness." So, according to the Bible, began the process of creation. Making light was the accomplishment of the first day. This was not the Big Bang that scientists today believe was how it all began; in the biblical account, God creates light on the first day, and on the fourth day he creates our sun, which gives us the daylight that enables us to see what we see.

We are the children of the sun, or so believed many ancient peo-ples whose legends reflected the awe with which the rising of the sun each day was greeted. Light was associated with many aspects of the human experience, including knowledge, safety, protection, majesty, divinity. As it dispelled the fears of the night and brought forth the day, it was considered to be of primal importance to the primitive mind. To the ancient Egyptians the sun was the eye of the god Ra, and the most elaborate of daily temple rituals took place at dawn, to mark the birth of the sun. The shape of the pyramids is said to have been inspired by

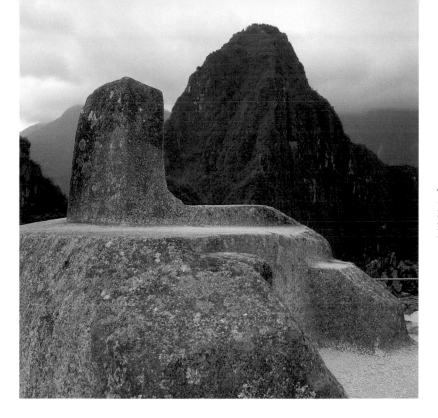

The stone
Intihuatana,
Machu
Picchu, Peru

the angles created by the rays of the sun. The setting of the sun was a
worrisome event, and in early societies there were methods designed to
prevent it from escaping. According to the anthropologist James G.
Frazer, the Eskimos of Iglulik tried to catch the sun in the meshes of a
string to stop its departure. He reported similar practices in Fiji and
New Guinea. Most disturbing was the shortening of days as winter
approached. High in the Andes mountains of Peru, in the "lost" city of
Machu Picchu, there is an extraordinary sculpture called by the Inca
"Intihuatana," meaning the mooring of the sun. The forms have the
kind of inner strength one would find in a monumental work by Henry
Moore. The upright column of Intihuatana was designed to mark the
solstice, and perhaps also to make sure that at its lowest point the sun
would not disappear altogether.

All of life seems to revolve around the sun. Without it, we could
not exist. Frazer stated that the ancient Mexicans named the sun god
Ipalnemohuani, which means "He by whom men live." This led to the
savage practice of feeding the solar fire by sacrificing the bleeding

hearts of men and animals.

A remarkable book entitled *Le Soleil, Mythologies et Representations*, published by UNESCO in 1993, depicts a vast panorama of representations of the sun in different cultures and through the ages. It shows images of the sun in ancient Japan, China, India, Pakistan Afghanistan, Indonesia, Russia, Greece, Egypt, Africa, and Pre-Columbian America. It also describes various mythologies in which the sun was a central figure. Symbols dating back to the Bronze Age are shown carved in stone. The book quotes references to "the resplendent sun" and "the egg of gold" in the Rig Veda. Isis, the god of fertility in Egypt, is shown with the sun god, Horus, on her knees, and a round shining disc as her crown. The book also cites religious structures around the world dedicated to the sun, such as the famous tenth–eleventh century "Temple of the Sun" in Khajuraho, India, which is covered with life-sized sculptures of gods in various positions of sexual embrace, perhaps representing the life-giving power of the sun. There is a photograph of a Neolithic sculpture of a symbolic phallus together with a round form representing the sun in Karakorum, Mongolia. In various places around the world the sun is shown in connection with godlike representations of birds, lions, bison, reindeer, serpents, cows, frogs, horses, and elephants. In an Aztec figure, the sun is shown between the thighs of a male figure as a symbol of fertility. Sun-discs are shown to have been represented on coins, tapestries, mosaics, frescoes, thrones, jewelry, costumes, pottery, and iron vessels. Renditions of the sun appear in paintings by Pissarro, Delauney, and Van Gogh. There are photographs of ceremonies around the world dedicated to the sun, including prayers to the rising sun on the Ganges, dances in the ruins of a temple of the sun in Quito, Ecuador, and celebrations of the New Year in Quanzhou, China. Solar interpretations are given to traditional symbols, like the Chinese Yin-Yang device, a circle bisected by a curving line, with half the space in black and half in white, representing the duality of the forces of nature—light and darkness, heaven and earth, masculine and feminine.

Although today we think of sun-worshippers as vacationers who seek to turn their skins to brown in summertime, we still sense the deeper significance of the sun to our inner lives. "The sun is a great heart," wrote D. H. Lawrence, "whose tremors run through our smallest veins." We can't connect with the spirit of the sun, he believed, "by

lying naked like pigs on the beach . . . We can only get the sun by a sort of worship . . . by going forth to worship the sun, worship that is felt in the blood."

On a bright day, when the sun lights up the world around us, we are invigorated by a sense of beauty. We recognize the sun as more than the maker of daylight. It is the creator of moods, the shaper of beliefs, the architect of thought. Our eyes translate what they see into inner experiences that, as Lawrence put it, connect us to the cosmos.

The breaking of dawn is a magical time. The light grows gradually and we are aware of a new beginning. This can be inspiring because of the promise of what lies ahead. When I was young, dawn was also frightening to me because I suffered from insomnia. I would become panicky when I began to see light appearing in my window, for it meant that I had been awake all night. Now when I see dawn, it is exhilarating to see the light growing brighter in the east and changing to shades of blue as the day breaks. It is the awakening of the world. The photographer Nelson L. (Lin) Carter made a series of photographs to track the sun emerging over the rim of the Grand Canyon and was "truly touched by the dawning of a new day with God's incredible sunrise." I have watched the dawn when traveling to different cities and rising early, as well as in airplanes traveling east on nighttime flights. Alone (or so it seems) at thirty thousand feet, I see the sunlight glisten at the edge of a wing while below night still shrouds the earth. This experience of seeing the sun rise from such a height is new to mankind, although our ancestors could have sensed it while standing on mountaintops, just as we can imagine what it must be like to someone looking out the window of a space vehicle.

As dawn passes into early morning, the light has a special quality of expectation. The foliage on a hillside suddenly springs to life. Sunlit trees are brilliant against dark backgrounds. In the city, the light glistens on the topmost windows of buildings. Deep shadows provide sharp contrasts. When the morning sun shines on water the earth seems to be on fire.

The day progresses, and the sun shines through the foliage of trees in summer, creating wisps of light in the deep shadows. In the winter it lights up the coating of ice that has formed around spare branches. When the sun is at midday the mystery disappears. All is revealed. Life is at its fullest.

Sunrise over the Grand Canyon. Photograph by Lin Carter

The striking difference between dawn and midday was once the subject of a discussion between Bertrand Russell and his friend and colleague, Alfred North Whitehead. Although they had collaborated on their monumental work, *Principia Mathematica,* they had different philosophical outlooks. Russell believed in what he called the "perpetual perishing" of all events that take place anywhere in the universe. He thought that every event that happens exists only for an instant, and when that instant is over, the event is gone forever. Whitehead, by contrast, believed in what he called "the eternal advance of the universe." He thought that everything that happens exists forever, as an element of everything else that is to come.

Russell reported that one day, when he and Whitehead were discussing their differences, Whitehead said that he looked at the world as it appeared in early morning, with long shadows stretched over the ground, while Russell looked at the world as it appeared at midday with the sun shining directly overhead. That explained why they held

opposing views. Whitehead insisted that neither could convince the other that his view was the correct one. Russell was upset by this argument, since he believed there could be only one truth about the nature of time and the universe. Either everything that is created perishes or everything lives forever. But on reflection he reluctantly concluded that Whitehead was right.

Midafternoon is quiet and mature. It can create a glowing presence, as when the sun lights up the side of a tall skyscraper or the slope of a mountain. The day is beginning to show its age, but it is still bright and cheerful.

Dusk is a moody time of day; there is a softness in the shadows that gives objects an unearthly character. Schopenhauer defined "the sublime" as what one feels when the setting sun lights the corner of a building, giving us a sense that there is more to the universe than we can possibly understand.

When the sun is sinking over still water, creating a line of light in its reflection, the effect can be mesmerizing. The poet Albert Goldbarth described the experience in these lines:

> We think the light is plangent and say
> Wow. I think the light was very plangent
> when I found her staring out the bedroom window
> at the orange spine the sun makes on the water as it sets. It set.
> She
> kept on staring. What she saw wasn't important
> then, I understood—what mattered
> was simply the looking itself, whatever
> of self-hypnosis and healing it held.

The sunset can be a glorious climax to the day of light. All the colors known to man, from one end of the spectrum to the other, can be in the sky, and when there are cloud formations the play of light and color is breathtaking.

The place from which one watches a sunset is a key factor in the mood it creates. As with a sunrise, seeing a sunset from an airplane is especially spectacular, for although night has already descended on the ground, there is still light in the sky.

Bill Baker, the president of public television station Channel 13 in

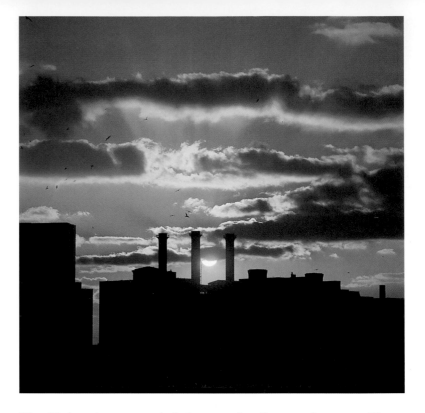

Setting sun over New Jersey

New York took some magical photographs of sunsets he saw on Henry Island, off the western coast of Cape Breton, Nova Scotia. Bill bought the teardrop-shaped island with its beautiful mile-long cove and beach, a few years ago. The west side of the island has cliffs over 100 feet high. The water is as clear and green as the Caribbean. Some say it is the warmest water north of North Carolina. The island has a beautiful lighthouse fifty-three feet high, against which Bill can watch the sun set over the trees. There is no electricity, telephone, or running water in the keeper's home, which adds to the solitude and remoteness that Bill and his wife enjoy. But Bill keeps his camera with him, and his photographs convey a mood no words could describe.

Whether on Bill Baker's island or anywhere else in the world, there is a feeling of finality when night arrives, and the moon and the stars come out. The specks of light against the black sky fill our minds with wonder.

Sometimes people have the good fortune to see something especially spectacular in the night sky. This could be a colorful display of

Above and left:
Late Afternoon on the Cliffs and *Sunset on the Lighthouse, Henry Island, Nova Scotia.* Photographs by Bill Baker

Northern lights, or a once-a-century comet streaking across the heavens. In a 1998 op-ed page article in the *New York Times,* Charles R. Eisendrath, a journalism professor at the University of Michigan, wrote about the "celestial light show" of the tremendous gamma and X-ray bombardment from a magnetar, a collapsed star that is believed to have a greater mass than the Sun, compressed in a sphere only 12 miles in diameter. He was on a fishing trip with some companions and was awakened by the guide around 10 P.M. This is what he saw:

> It started with a Rothko-like vertical glow in the north, in the manner of many northern lights. But within a minute or two, a shimmer of the palest green appeared in the east. Then someone noticed that the same thing was happening in the southeast, where northern lights don't normally appear.
>
> A cloud overhead covered the eastern half of the sky. Suddenly, a gigantic bridge of light crossed the horizon, lining north with southeast. The cloud began glowing an ice blue and turned silver at the edges, where it began to ripple gently, like fur fringes on a parka with the sun behind it.
>
> Within 10 minutes the sky was writhing, as if some huge thing might fall out of it. The light bursts reminded me of nuclear tests in the old Army films. My ears strained because it seemed impossible for something so violent and so immediate to be silent. The event seemed to call for explosions, or maybe Beethoven.
>
> Something about it intimidated the wolves. We were quiet, too—until as if with a switch, the theater went dark. What else was appropriate? We applauded.

Objects that seem to contain the light of the sun and the stars, like gold, silver, and jewels, are considered precious—if not holy—and they were used by medieval painters to decorate images of heavenly beings. They depicted angels with golden halos around their heads and jewels in their robes. Heaven itself was shown filled with shafts of golden light. The whiteness of ivory has been treasured since ancient times; in medieval carving it was considered an ideal material to represent the Virgin because of its purity. Gold shines with magnificent brilliance in illustrated manuscripts that are the treasures of great libraries around the world.

One of the reasons that some jewels have long been considered to be of extraordinary value is because of the way light is refracted in them. The philosopher George Santayana thought of jewels as objects that have a remarkable spell about them. He believed there was an inexhaustible mystery about them, that we could not fathom the secret of their hardness and their dazzling brilliance. Santayana likened the mystery of jewels to the mystery of the feminine and thought this might explain the fascination jewels have for women. In Edmund Spenser's *Fairie Queene*, Arthur's shield was as flawless as a diamond, "perfect pure and cleane." When fighting Orgoglio, the shield cover falls off, and the "heavens light" of the jeweled shield dazes Orgoglio, and enables Arthur to win the battle.

Religious writers of many faiths have described divine light as an emanation from God. "The righteous will shine like the sun in the kingdom of their fathers" (Matthew 17:2). Thomas Aquinas believed that "the bodies of the blessed will shine seven times brighter than the sun." The Tibetan Book of the Dead speculates that when the mind and body separated, one would be able to see the Primary Clear Light. "It is said," the book explains, "that it is like a mirage, subtle but bright, dazzling in its radiance . . . Within this light there is also the sound of ultimate reality, like a thousand simultaneous thunder claps." Afterward, one would experience "the day of pure white light of the Eastern realm of transcendent happiness and mirror-like wisdom . . . the day of the pure yellow light of the Southern Realm, the realm of giving-feeling equality . . . the day of the western realm of meditation, perception and wisdom. . . the day of the pure green light of the Northern Realm of willing-achievement."

In Dante's journey to Paradise (*ciel ch'e pura luce*), he saw "a shining host illuminated from above by burning rays."

The spiritual light of imagination came to earth through the ingenious invention of stained-glass windows. According to the Czech-Austrian art historian Max Dvorak they brought divine light into the human experience in a unique way. These huge windows were "immense walls (which are not walls at all)," circumscribing the interior area of the churches and establishing a connection with infinite space. The union represented "the conquest of free space itself," with natural, falling light which penetrated colored panes of glass, and "transformed into various shades of color [radiating] with a mystically

gleaming force from the very figures in the windows." They were heavenly figures unlike anything ever before seen—"a veritable miracle of transfiguration."

Another art historian, Julius Lange, wrote that when one sees the setting sun through stained-glass windows, "the sensation of fire permeates all, and the colors sing out, rejoicing and sobbing. In truth, this is a different world."

Anyone who fails to be dazzled by stained-glass windows is missing one of the great sights of the world. I remember the first time I was overwhelmed by such a sight; I was in Milan Cathedral and I saw the enormous glowing windows shining out of the darkness of the vast interior space. Since then I have seen stained-glass windows in churches all over Europe, and have never failed to be amazed by them. When the writer Harold Brodkey was reflecting on his imminent death from AIDS, he remembered seeing Chartres almost fifty years earlier. Although he had read and spoken to others about the cathedral before his visit, he had not been prepared for the beautiful colors he saw in the air around him—the delicate blues and yellows lit by the stained-glass. He felt that he was inside a work of genius. It was like a great theater, with the light changing from minute to minute, sometimes darkening as a cloud passed, and then bursting again with brilliant light as the sun returned. It made an impression that he never forgot.

The huge circular windows of medieval cathedrals were especially meaningful, since they were intended to unite the light of divinity and the circle of perfection, and thus were the ultimate symbols of God's presence. One of the most beautiful rose windows I have seen is by Andrea Orcagna in the Cathedral of Orvieto, Italy. Orcagna was a master of color and light. Before I saw the window at Orvieto, I had photographed virtually every inch of his magnificent tabernacle in Orsanmichele, a church in Florence. There, he had used colored glass in ways that I had never seen before, painting in rich colors on the back of cut glass to give the effect of mosaics that glowed. There are more than one hundred sculptures in the tabernacle; some of the colors were on the narrative reliefs, and others were part of the beautifully designed decorative motifs. Similar decorative motifs with glowing colors made the rose window in Orvieto a superb masterpiece of form and color.

The Pre-Raphaelites in the nineteenth century delighted in the design of stained-glass windows. So did Chagall, Matisse, and others in

the twentieth century. For them the graceful lines of the figures they drew were as important as the colors that shone in the light.

The miracle of gold and the brilliant colors of mosaics brought a different kind of spiritual light into the world of Byzantium. The gold in Byzantine paintings seems to give them a quality of extraordinary holiness. So does the gold in the mosaics in Istanbul, Venice, and Ravenna. In Rome's church of Santa Prasseda, there are spellbinding mosaics dating to the ninth century; the vaulted interior of one of the chapels has been called—for good reason—"The Garden of Paradise." In the Baptistery of Florence, time seems to stand still when one sits on a bench and looks at the mosaics in the vault with opera glasses, marveling at their details.

The poet W. B. Yeats was profoundly moved by the spiritual aura of Byzantine works, and in his poem, *Sailing to Byzantium*, he pleaded:

> O sages standing in God's holy fire
> As in the gold mosaic of a wall,
> Come from the holy fire, perne in a gyre,
> And be the singing-masters of my soul.

The spiritual quality of gold figured even more intensely in his second poem on this subject, called simply *Byzantium*, where he wrote about the miracle of "golden handiwork," of golden boughs and birds, and finally of spiritual fire:

> At midnight on the Emperor's pavement flit
> Flames that no faggot feeds, nor steel has lit,
> Nor storm disturbs, flames begotten of flames,
> Where blood-begotten spirits come
> And all complexities of fury leave,
> Dying into a dance,
> An agony of trance,
> An agony of flame that cannot singe a sleeve.

The "light of divinity" is what many have reported seeing in near-death experiences. An uncle of mine, who was very learned and very devout but not especially mystical in his outlook, devoted himself to study and writing until his mid-nineties. He once asked me to do him a favor and

Sun streaming
through
clouds

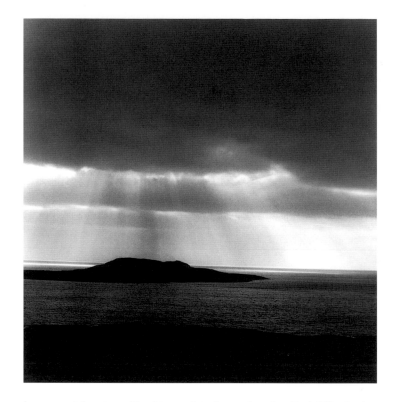

make a special point of looking at his face when he died. If he had seen some great light that is visible only at the point of death, he would have a smile on his face; if he died in pain his face would have a grimace. He evidently wanted to send a message back to the living, and I promised to do as he wished. However, shortly before he died there was a block-age in his intestines that caused him intense pain, and I saw his face contorted in agony. Soon afterward he fell into a coma. For two days he lay still. He looked saintly and at peace, but I knew it was because he was unconscious. When he died, he simply stopped breathing. Unhappily, I was unable to detect a signal as to whether or not he saw the light of heaven.

When we dare to look in the direction of the sun, the light is too strong for our eyes. But it is thrilling to see the wonderful sights cre-ated by the sun when it lights up sections of clouds. Their billowing forms, whether seen from above or below display spectacular grada-

tions of light and shadow. Rays of sun streaming through clouds are amazing to behold. And when the sun lights up enormous clouds rising thousands of feet into the sky, they look like pillars of fire.

The sun creates changing pools of color when refracted by glass or other transparent substances. When it hides behind the moon during an eclipse, the light seems eerie, as if we are on another planet. The same is true when the sun disappears in a heavy storm and the sky is extraordinarily dark, producing the atmosphere of twilight in the middle of the day. Rainbows, the sign God gave to Noah as a promise that there would be no more floods, produce a sense of awe when they appear at the end of a rainstorm.

Other kinds of light evoke different experiences. The jagged lines of lightning are unlike anything else produced by nature or mankind. I caught one of those lines by accident when I was photographing a laser sculpture in the night sky over Johnstown, Pennsylvania. The juxtaposition of the laser beams and the lightning streaks made a striking composition.

A famous work of art that capitalizes on the forms lightning takes was created by the "earth artist" Walter De Maria, with "The Lightning Field"—four-hundred glittering stainless-steel poles with solid, pointed tops that attract spectacular bolts of lightning in a valley rimmed with mountains in Catron County, New Mexico.

Light coming from a window was the hallmark of paintings by the painter Jan Vermeer in seventeenth-century Holland. Light coming from a candle provided a similar inspiration for his contemporary, Georges de la Tour of France. Light from unidentified sources inspired Caravaggio's dramatic paintings. Light from the sun was the subject of many of J. M. W. Turner's golden paintings. Fascination with the science of light led to the school of Impressionist painters in the nineteenth century, and the mystery of light to the white paintings of Mark Tobey, Richard Pousette-Dart, and Robert Ryman in the twentieth century.

A new world of light came into being when Thomas Edison invented the electric bulb. Now in virtually all parts of the world electricity creates almost as much light artificially at night as there is naturally during the day, and what was once the stark difference between day and night is much less dramatic. As the day fades, streetlights come on in cities as a surrogate for the sun, and new relationships between

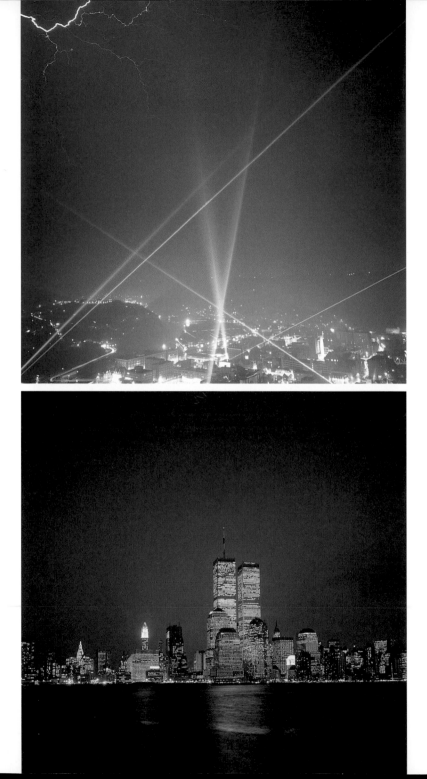

Laser sculpture
and lightning
over
Johnstown,
Pennsylvania

Manhattan
skyline at
night

light and dark come into our lives. A view of downtown Manhattan at night, with all the lights shining from office windows, is jewellike. Inside our homes we have become used to effects created by lamps that show objects quite differently than they appear in daylight. The artist Dan Flavin developed works that showed pools of light created with fluorescent lights of different colors. Chryssa designed abstract structures of fluorescent strips. Bruce Nauman produced suggestive neon signs, one of which stated, "The true artist helps the world by revealing mystic truths." The photographer Andres Serrano experimented with objects immersed in a variety of fluids and lit in a way to show their forms—including a controversial image of a plastic crucifix submerged in a container of urine.

Oceanic sculpture, Metropolitan Museum of Art, New York

Thus the sun and its modern counterparts in electric lights are the keys to the way we see the world around us. Each of us responds to what we see in our own way. Overcast days may depress us; foggy days may baffle us; days with a blazing sun may open our hearts to the joys of being alive; nights with a full moon—or a display of stars without the moon—may open our minds to the vastness of the universe. What we see is a function of what the light does to our minds. Sunrises and sunsets are among the most dramatic sights any of us have ever seen. The bright overhead sun of the equator inspired Oceanic and African sculptors to create works with sharp angles and deep cuts so that the sun's highlights and shadows intensified their power. Light is the key to what we see and what we feel about what we see. Without light, there would be no experience of seeing by anybody of anything.

CHAPTER THREE

Walking
in the
City

ONE OF MY FAVORITE BOOKS AS A YOUNG MAN WAS Alfred Kazin's *A Walker in the City*. It was published in 1951. I didn't realize at the time that Kazin was just a few years older than I was when he wrote the book; I was thirty and he was thirty-six. I assumed the book had been written by a much older man who was looking back on his childhood. I also thought—mistakenly as I learned much later—that the book had been written with the utmost ease, since the language flowed so smoothly and the anecdotes and descriptions seemed to pour forth almost as if in a single breath. The charm and simplicity of the book made a deep impression on me. I identified with the memories of the author's youth, growing up in Brownsville, a section of New York in which my grandfather had been a revered rabbi.

More than forty years later, Alfred and I became good friends. We were introduced to each other by our mutual friend Harry Abrams, who had the idea that we would make good collaborators on a book he had thought of, to be called *Our New York* (it was eventually published by Harper & Row). In the course of working on that book,

Alfred and I walked through many parts of New York together, and we talked both about what the city was like now and what it had been in the past. And I did a lot of walking on my own to discover a myriad of things I had never looked at before in the city I had lived and worked in all my life.

In the course of working on that book I saw with a fresh eye the beauties of the cathedrals and other churches that are all over the city, the decorative features of buildings built at different times, the depressed areas with burned-out tenement houses, graffiti everywhere, billboards in strange places, beautiful parks, monumental bridges. It seemed to me that it would take an encyclopedia to contain all the sights I looked at through my camera lens. Subway stations. Views of the rivers surrounding Manhattan. Parking lots. Cemeteries. Military recruiting stations. Telephone wires. Lampposts. Schools. Elegant brownstone houses. Abstract patterns of windows on tall buildings. Stores. Museums. I even flew over the city in a helicopter to get a bird's-eye view of New York and see glorious views of the skyscrapers in lower Manhattan and the Throgs Neck Bridge curving from Long Island into the South Bronx.

The people I became aware of were equally diverse. A man selling newspapers. Another selling hot dogs. A boy fishing under a bridge. Students eating lunch on a park bench. Women shopping. Women talking. A bag lady sitting on a stoop. People sitting on a bench to pass the time. A policeman looking at me suspiciously. A man getting a shoeshine. A mother and child waiting for the light to change. A stream of people crossing a street. Youngsters playing basketball. Others playing in water from an open hydrant. A man taking a picture of a woman in front of a sculpture. A child playing in the park. People in a rowboat. People on bicycles. People lying in the sun. A man eating an ice-pop. A couple embracing.

One of my favorite shots was taken from a car window when I happened to see a man reading a book while walking. I didn't even notice a second man sitting in a doorway until I made the print and realized that the two together—who obviously had no connection with each other but had been caught in the same frame when I happened to snap my shutter—made a statement about all of us being absorbed in our own worlds and being oblivious to others while we move about our bustling city.

Man reading book while walking in New York, from *Our New York*

What did it mean to look at all this with a fresh eye? Why did I consider it a revelation? Why did so many familiar sights now look so different? It was because I had never looked so intently at the scenes of daily life before. And as I looked through my viewfinder, my mind gave new meaning to what I was seeing. I saw more than what was there because I was paying such close attention to what I was photographing. The people were not only anonymous passersby; they each had a life of their own, and in my imagination I could speculate about their individual stories. If I had been a novelist, I would have discovered plots within plots unfolding in front of my eyes. As a poet, I would have been inspired by flashes of insight. As a painter I would have had a vast panorama of subjects to choose from. As a photographer, which is what I was as I wandered through the city, I was capturing moments of life that only I could see and were my personal discoveries.

In his book, *The Forgotten Ones*, photographs by Milton Rogovin taken in Chile, Mexico, France, Scotland, Spain, and the Jewish

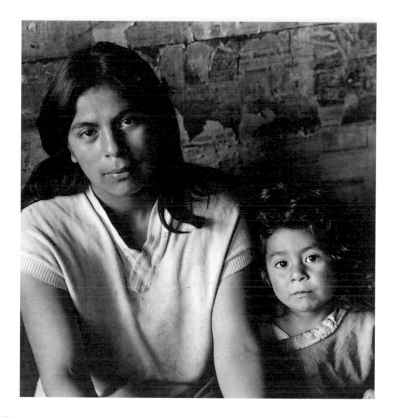

Woman and child.
Photograph by
Milton Rogovin

Yemenite community in Lackawanna, New York, were of people who might never have been photographed by anybody. In describing Rogovin's visit to document the peoples of the islands off the coast of Chile, Pablo Neruda, 1971 Nobel Prize winner for literature, stated: "[H]e carried much more than his equipment. Patient eyes and searching. A heart sensitive to light, to rain, to shadows . . . The great photographer immersed himself in the poetry of simplicity." The cover photograph, one of the most moving in the book, is of a woman and child who seem to be looking at the photographer with questioning eyes, asking "Why do you want to take any photographs in this poor and ugly place?" And the camera answers back, "Because you are beautiful!"

Taking a different approach, but perhaps with a similar idea in mind, the photography editor of the *New York Times* magazine section, Kathy Ryan, commissioned nineteen photographers for the May 18, 1997, issue devoted to Manhattan's Times Square. The idea was that

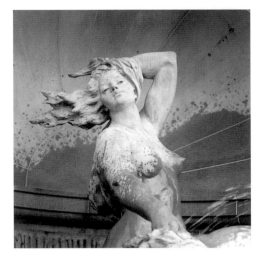

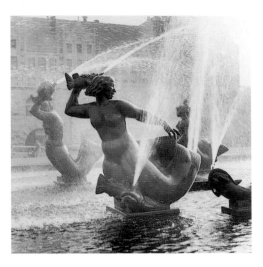

Above left:
Sculpture
by Roland
Perry, from
the Library of
Congress,
Washington,
D.C.

Above right:
Carl Milles,
*The Meeting
of the Waters*
(detail),
St. Louis,
Missouri

Times Square was a special place, where all sorts of dramas have taken place over the years. At one time it was the neon capital of the world; at another, it was a center of crime and squalor. At any time, it should be a fascinating subject for photographers. The photographs included a variety of street scenes and portraits, a hotel room overlooking the street lit up with reflecting lights, movie theater-goers, a massage parlor room, a man in a shooting arcade, a detention cell in the Port Authority, the performance at a late, late show at a drag club, a worker on a scaffold. Here the photographers not only portrayed the places and people they saw, they made a social commentary on life in the heart of the big city.

I had a very different idea in mind when I took a series of photographs in Washington, D.C. There, my subject was not people and places, but sculpture. A friend of mine, Arthur Levitt, Jr., had purchased a small newspaper called *Roll Call*. It was a newspaper designed to be of local interest to members of the Congress, and in the past had been supported by advertisements from local restaurants and other merchants. Arthur had the vision to see it as a medium that could be of interest to national advertisers who wanted to convey messages to Congress. He also felt the newspaper could become an important editorial vehicle that reported on the weekly activities of the government. Soon after Arthur acquired the newspaper, I volunteered to produce a

regular feature that would focus on public sculptures in Washington to help members of Congress be aware of the multitude of monuments that were in the nation's capital. Arthur was delighted, and over the next several years I produced about thirty such features. In each case I took many photographs of each monument, to help readers learn how to look at objects which otherwise were given only a passing glance. I hope it made some impact on the esthetic sensitivities of those responsible for the laws of the land.

There are some remarkable sculptures in interesting settings in many cities, and too often they are totally ignored. The recent explosion of sculpture parks—in Europe, Japan, the United States, and probably elsewhere in the world—helps to draw attention to the many ways in which three-dimensional works of art interact with landscapes to produce unique experiences. Part of my mission as a photographer is to

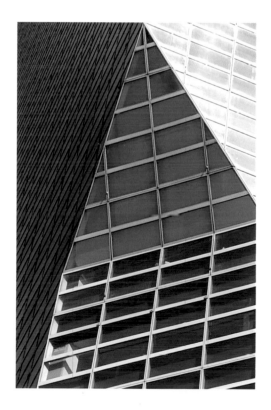

Detail of a skyscraper. Photograph by Roxanne Abrams

encourage people who live in cities to appreciate the outstanding works they have in their own midst. I once published a book called *Sculpture City, St. Louis,* because that city, with its extraordinary "Arch" by Eero Saarinen; its Milles Fountain called "The Meeting of the Waters"; its monumental steel structure by Richard Serra; its Laumeier Sculpture Park near the center of the city, and many other works, is one of the world's great treasure houses of contemporary sculpture.

If you concentrate on opening your eyes even when you are walking down a street that you pass by every day of your life, you may discover something you had never noticed before and that opens a new world for you. The photographer Roxanne Abrams looked up one day and found a detail of a skyscraper that made a fascinating composition. The photographer Bill Rivelli pointed his camera at a mysterious detail of a church. You, too, can walk around the city—with or without a camera—and find an endless number of points of concentration that can be esthetically uplifting.

The other day I saw a tree right in front of the office building in which I work; I couldn't believe that I had never noticed it before and I admired its wonderfully graceful branches. At another time, I saw some carving on the face of a tenement and found myself thinking about the architect who conceived the design, the craftsman who created it, and their excitement that this would now be on public view—a view that, for all I know, no one had bothered to look at for years. I found signs on the street with public notices that looked intriguing. On a cold winter day, I saw a policewoman directing traffic and speculated about the clothes she must be wearing to keep herself warm. There were stores and restaurants I had never looked at; in one window there was an ingenious display of old locks designed to catch the attention of passersby, but until that moment it had failed to do so with me. There was a public school down the block I had never paid attention to, but in midafternoon crowds of teenagers were standing on the street and I thought about their different personalities and the way they dressed and talked to each other. There was a strange antique shop right next to our building in which I rarely saw a customer; I had glanced in the window from time to time, but one day I saw a fantastic clock unlike anything I had ever seen before, but which apparently had been there for a long time. On my own building, right below the windows of our third floor offices, was a string of posters I had never noticed—plas

tered on a temporary structure built over the sidewalk. Around the corner was one of those curious conglomerations of signs that make a city look so chaotic, including one especially amusing poster of a bare-backed man upside down.

Sometimes, when I walk down a familiar street, I look around to see if I can make new discoveries. It's a game I can never lose. I'm always amazed at how blind I have been to the sights that are there. I had a similar experience when I took the photographs for a book on New Rochelle, New York, a city in which I have lived for over forty years. I've driven all over the city on various errands, and yet for the first time I moved through the city with my eyes opened wide. I was amazed to discover through my camera eye streets, parks, playgrounds, college campuses, hospital buildings, nursing homes, libraries, fire sta-tions, stores, schools, lakes, brooks—most of which I had never noticed before.

A friend of mine, Anne Matson, had a similar experience while walking on a lunch break near her school, the School of Visual Arts, in New York's West Village. Her camera eye caught sight of a row of beat-en up trash cans, and on that sunny day they looked beautiful to her.

Returning to old haunts revives memories and stirs new thoughts. Every year for the past thirty years or so, my wife and I have spent a week in Florence, Italy, at least twice a year. It's a city we love to walk in, and its treasures are endless. Coming back to Florence is a way of taking a measure of our lives. Often we walk by ourselves for part of

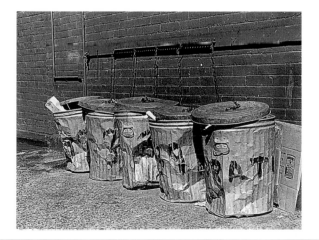

Trash cans in New York. Photograph by Anne Matson

the day since we each have our own favorite places. When I walk by the Arno River and look at the reflections during the day or night, or walk down the narrow streets and see the details of the Renaissance buildings with which I am so familiar, or enter the magnificent piazza across which I see the Duomo rising majestically into the air, I feel both a renewal and a reappraisal of what my life has meant to me since my last visit. I may stop at the river and study the base of a lamppost, wondering about its design, or think about an iron fitting on the inner wall of the Bargello Museum and try to figure out what its function was a few hundred years ago. It is almost as if I can at such moments come to grips with some profound knowledge that I have never quite grasped before. I cannot put into words or even think clearly what that knowledge might be, but I feel in my heart that somehow the moment is a landmark in my life.

Siena, Rome, and Milan are other cities in Italy that my wife and I frequently visit, and we make rediscoveries in those places, as well—sometimes just the shape of an ancient light fixture, or a view of the sky past tops of buildings on a narrow street.

In Jerusalem, Istanbul, Genoa, and many other cities, I enjoy walking through the old quarters that have remained the same for hundreds of years. In London, my favorite place is Charing Cross Road, where I can spend hours in secondhand bookstores. In Paris there are the familiar streets leading up to all the museums I love to visit—the Louvre, the Jeu de Paumes, the Musée d'Orsay, the Cluny, the Guimet, l'Art Moderne, the Pompidou.

Sometimes hotels stand out in one's memory. In the small medieval town of Asolo in Northern Italy, where Browning wrote his poems for the volume called *Asolando*, there is a tiny hotel called Villa Cipriano. We stayed there when I was working on a book on the sculpture of Antonio Canova, who had lived in a nearby town, Possagno. I made a note of the room—No. 102—a corner, with a terrace, and a breathtaking view of the Italian Alps. On the Island of Skye, off the western coast of Scotland, I made a note of a room in the Flodigary Hotel—No. 3—that has a spectacular view of the ocean, the hills on the shore, the constantly changing sky. Then there are the luxury hotels of the world where it is the atmosphere, the grandeur, the elegance, the air of self-importance that makes a most striking impression.

It is not only the atmosphere of a grand hotel that seems exciting,

it is the part of the city in which it is located. Claridges is in the middle of the West End in London, near Bond Street, with its elegant shops and galleries. The Hassler is at the top of the Spanish Steps, with a glorious view of Rome in the distance. In Paris, the Ritz is on Place Vendôme, a beautiful open space, and a short walk from the great shops of the city as well as the Tuileries and the Louvre. These hotels are all in the hearts of their cities, and great starting places for walks.

What do *you* look at when you are a walker in the city? The photographer Babs Armour had the imagination to capture with her camera street reflections on windows intermingled with the objects inside, producing surreal images. Do you look at store windows the same way she does, or do you look down at the pavement or up at the sky, or at nothing in particular? Is your mind focused on other thoughts as you

Street scene. Photograph by Babs Armour

try to get where you're going as fast as possible? When you stand at the corner waiting for a traffic light to change, does your eye wander to see what is happening while you wait, or do you just stare at the sign that reads DON'T WALK, waiting for it to change? Is the time you spend walking in the city a meaningful experience, or is it just a period empty of meaning—distracted from distraction by distraction, as T.S. Eliot once described our apathetic moments in "this twittering world"?

Walking in the city can be any or all of these. One can walk in the streets of the cities all over the world and sense their individual personalities. Over the years I have walked in perhaps a hundred cities, and each one has been a different experience.

When we are visitors we

Detail of the Column of Trajan, Rome

make a point of seeing the landmarks, and we try to sense what is special. In New York, all visitors look at the Statue of Liberty as the symbol of America. I remember a speech once given by President Vigdis Finnbogadóttir of Iceland when she arrived in New York for the first time. She said that when her air-plane flew over the New York harbor and she looked out the window, it was not the towering skyscrapers of lower Manhattan that caught her eye, she said, but "that Great Lady" standing on her pedestal that gave her what she said was an indescribable feeling. People look with the same spirit of wonder at "Big Ben" in London, the Eiffel Tower in Paris, the Forbidden City in Beijing. When I saw the Taj Mahal in India, I had to pinch myself to be convinced that I was there. When I saw the Great Pyramid in Cairo I was amazed to see those enormous stones that slaves, some of whom were probably my ancestors, had so expertly placed next to and on top of each other.

When one visits a city often, there is a tendency to take monu-ments for granted. I don't know how many times I passed by the Column of Marcus Aurelius on my frequent trips to Rome without bothering to look at it carefully. But one day I studied the bas-reliefs which ascend in a spiral for roughly 100 feet and was amazed by the details of this work created in the second century A.D. The experience also inspired me to examine the Column of Trajan, which is even taller (125 feet) and which is located in a section of the Forum to which I had previously paid scant attention. Trajan's column, created a few decades earlier than the one honoring Marcus Aurelius, is considered one of the finest sculptural works created by the Romans. It, too, features a series

of reliefs spiraling upwards. As I looked at the more than 150 scenes in the long narrative, I felt an uncanny, almost physical closeness to the life of ancient Rome.

Cities have their own distinction, even when the clusters of tall buildings in the center tend to look like tall buildings anywhere in the world. Carl Sandburg touched on both their commonality and their differences in "The People, Yes":

> Tell it to us, skyscrapers around Wacker Drive in Chicago,
> Tall oblongs in orchestral confusion from Battery to Bronx,
> Along Market Street to the Ferry flashing the Golden Gate
> sunset,
> Steel-and-concrete witnesses gazing down in San Antonio on the
> little old Alamo,
> Gazing down in Washington on the antiques of Pennsylvania
> Avenue; what are so
> near my feet far down?
> Blinking across old Quaker footpaths of the City of Brotherly
> Love: what have
> we here? Shooting crossed lights on the old Boston Common:
> who goes there?
> Rising in Duluth to flicker with windows over Lake Superior,
> Standing up in Atlanta to face toward Kenesaw Mountain,
> Tall with steel automotive roots in Detroit, with transport, coal
> and oil roots in Toledo, Cleveland, Buffalo, flickering afar to
> the ore barges on Lake Erie, to the looming chainstore trucks
> on the hard roads,
> Wigwagging with air beacons on Los Angeles City hall, telling
> the Mississippi traffic it's nighttime in St. Louis, New
> Orleans, Minneapolis and St. Paul—

The characteristics of different cities come to mind if one travels a lot, as Carl Sandburg did around America, and as Walt Whitman did before him when he "sail'd down the Mississippi . . . wander'd over the prairies . . . bathed in the Eastern Sea and again on the beach of the Western Sea . . . roam'd the streets of inland Chicago." Cities, like people, have personalities, and when we walk the streets with peering eyes, we have a glimpse of what those personalities are like.

CHAPTER FOUR

Communing with Nature

THERE IS A DIFFERENCE IN THINKING ABOUT *NATURE* as "the created world in its entirety" (Webster's definition) and *nature* as a place where one can have uplifting experiences. Looking at, or reading about, or seeing an image of such a landscape can evoke a special kind of emotional response.

That is true even when the object of attention is one of the smallest parts of the natural world. In a book on mentoring entitled *Athena's Disguises*, the classical scholar, Susan Ford Wiltshire, wrote about her friend Rachel Maddux, an inspirational writer acutely sensitive to nature. Rachel's discovery of the French naturalist Fabre and his minute observations of the whirling life contained in a tiny square of grass, opened her eyes to the wonders of the world around her. Inspired by his observations, Rachel wrote:

> a landscape no longer looks like a picture postcard to me, static and finished and still, I no longer see a tree and over it the sky and under it the grass. Many many things are *going on* in that land-

scape and now I know it all the time. I look. Even looking from a distance I know it. For in the tree is a bird and on the bird is a louse and on the louse are bacteria. And from the branches of the tree hang beautiful complex spider webs and in the tree is a spider with her foot upon a sensitive telegraph wire attached to the web at the place of maximum communication.

Castle overlooking the countryside of Ireland

The reality of nature is infinite and one can look at its details endlessly. But there is also a sense of unreality that one can discover in nature, a connection to another world. That is the stuff of which legends are made. "In that open field," wrote T. S. Eliot in *Four Quartets*, "If you do not come too close, if you do not come too close, / On a summer midnight, you can hear the music / Of the weak pipe and the little drum / And see them dancing around the bonfire."

I came close to seeing those mysterious figures in a strange adventure many years ago. When our children were young, my wife and I used to take them on trips to different countries to give them an oppor-

Ben Bulben

tunity to see something of the world. One summer we took our two youngest children, Peter and Amy, to Ireland. They were both teenagers, and we had a wonderful time exploring the countryside. It was exciting to come across old castles and churches in the midst of rolling hills in the lush part of the country. We were moved by the loneliness of the desolate, rocky landscape in counties Donegal and Sligo, with their scraggly trees and strange stone fences stretching across open fields. Here and there we came across ancient dolmens, with large stones on each side and a stone slab on top, usually slanted toward the sky, standing in the midst of those fields. The dolmens were not marked or treated as monuments but could be seen just as part of the landscape. These remarkable structures gave us a sense of being in direct touch with the people who made those burial sites eons ago, well before the beginning of recorded history. On the west coast we

saw the enormous, and in some ways frightening, cliffs of Moher.

When it rained, which it did often, it seemed as if the dark sky and gray stones on the ground became one. I remembered the wonderful descriptions by the poet John Millington Synge of the Aran Islands, which lie a few miles off the west shore of Ireland. "Looking out over low walls on either side into small flat fields of naked rock," he wrote, "I have never seen anything so desolate. Grey floods of water were sweeping everywhere upon the limestone, making at times a wild torrent of the road, which twisted continuously over low hills and cavities in the rock or passed through a few small fields of potatoes or grass hidden away in corners that had shelter." I thought also of the novels by Walter Macken, particularly *Rain on the Wind,* in which he described the discovery of "a fairy tree" on which blossoms lasted longer than anywhere else in the world. And when we came to the town of Sligo, I recalled those old tales by Lady Isabelle Gregory, who contributed so much to the renaissance of Irish literature, and I felt the presence of the poet W. B. Yeats all around me.

It was an eerie feeling to see Ben Bulben, the mountain that had inspired W. B. Yeats's famous poem, "Under Ben Bulben," when the aging poet had a vision of his final resting place:

> Under bare Ben Bulben's head
> In Drumcliff churchyard Yeats is laid.
> An ancestor was rector there,
> Long years ago, a church stands near,
> By the road an ancient cross.
> No marble, no conventional phrase;
> On limestone quarried near the spot
> By his command these words are cut:
> > *Cast a cold eye*
> > *On life, on death.*
> > *Horseman pass by!*

We visited that little churchyard where he was buried and saw those last three lines carved on Yeats's own tombstone. We thought long and hard about their enigmatic message inspired by a vision of a reality beyond the here and now, with its image of a courageous horseman riding toward some unknown destiny.

Our own otherworldly experience occurred when we came to another promontory on top of which was a strange elevation called Maeve's Mound. From the distance the Mound looked like an oval rock on the crown of a hill, but when we got closer we saw that it was a strange, unearthly pile of ancient stones some two hundred feet in diameter and eighty feet high. Maeve was a queen of Connacht, who, according to legend, was thought to have lived some two thousand years ago; this cairn was said to be her grave.

We drove our car as close as we could get to the foot of the hill, and when the small dirt road ended we saw that although the ground was quite barren, with no trees and virtually no shrubbery on the slope, there was a vaguely defined path that led up to the top. Peter, Amy, and I decided to see if we could climb up the steep incline and take a close look at this prehistoric monument. My wife decided to stay behind; she sat in the car knitting while we started on our hike.

The slope was unusually steep, with virtually no shrubbery, and we realized that the distance to the top was further than we had thought. We walked at a pretty swift pace, but began to realize that we might not want to go all the way. Peter became impatient and said he would like to run ahead since he was determined to make it to the top. Neither Amy nor I felt that committed, and we told Peter that we would either meet him on top, or if we decided we had had enough, we would meet him on the way down. Soon we saw Peter disappear over the top of the hill. We took our time and walked slowly ahead. Finally we found ourselves on the last lap, and with a little extra effort made it to the top. I was surprised to find that the surface was flat and round, I made a mental note of a small bush at the point where we emerged to make sure I could find my way down.

Maeve's Mound, which had looked rather small from below, turned out to be an enormous pile of stones. But when we arrived in front of it there was no Peter! I thought he must be on the other side of the mound, so I told Amy to go around to the left and I would go around to the right. We met in the back, but to our astonishment, there was still no sign of Peter. Amy became frantic, and I was anxious myself. We went back to the other side of the Mound and called Peter's name as loudly as we could, to no avail. I couldn't believe it. Peter was lost. Maeve and her otherworldly companions had apparently whisked him away to another realm. I felt as if he had been captured, that there

would be no way to rescue him, that we would never see him again. Amy began to sob hysterically.

I had read the stories by Lady Gregory and W. B. Yeats about those whom she called the faery people of the Gaelic race, and how boys and girls and all sorts of people were said to have been taken away to a secret and invisible land. When one is in that part of Ireland and looks at the barren countryside, there is an almost palpable sense of mystery in the air. If ever there is a place to believe in otherworldly spirits this is it. I didn't *really* believe he had been carried away, but what if he had?

A more rational explanation, which was almost as bad, was the possibility that Peter had not made a mental note as I had done of the bush at the end of the path, and had started down the hill on the other side. That would have brought him miles away from where Laura was waiting in our car. What would he do when he got down? I asked myself. We were not registered in any hotel. We were just driving through the countryside with the idea of selecting a hotel randomly at the end of the day. There was no way that he could reach us, nor we him. Amy continued to cry, and I was close to tears myself.

After a few more moments of yelling at the top of our lungs, I decided we had no choice but to start down the path and return to the car. We kept yelling as we descended, but there was no response. Soon we saw our car parked at the bottom, and I said to Amy, "Maybe we'll be lucky and find Peter in the car." "If he's there," Amy said, "I'll kill him!" We held our breath as we got closer, and when we arrived at the car, there, sitting calmly in the back, was Peter! Of course, we were relieved, but we were also baffled. Then, looking up, we realized that there was a point at which the path split in two. Peter had been coming down one leg of the path while we were going up on the other, and we had been blocked from each other's sight by a pile of rocks in between.

Neither Amy nor I will ever forget that experience. For those few moments we almost believed that some otherworldly creatures had taken Peter off to the land of myth and legend, and that there would be no way to get him back.

I suspect that it is not unusual for mountain climbers to have a sense of something like the supernatural when reaching their destinations. Straining oneself to master a steep climb, rising higher and high-

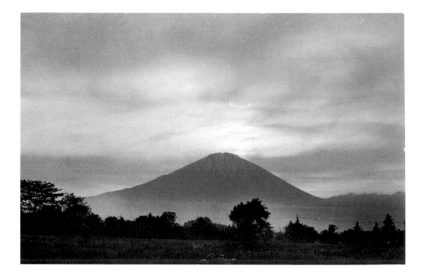

Mount Fuji

er over rocks and across streams, and finally arriving at a clearing where one has a magnificent view of the valley below and mountains in the distance, one can feel a little nearer to the heavens. Mountain climbers in the Alps and Himalayas have described the exhilaration they feel on reaching their ultimate goal and looking out at the panorama before them. A friend of mine, Bill Phillips, one of the leaders of Outward Bound, recently told me about how exciting it was to climb Mt. Fuji in Japan and watch the dawn come over the horizon from that impressive height.

We probably felt—or thought we felt—some mystical vibrations underground when we stood next to Maeve's Mound. The art historian Kenneth Clark took such vibrations seriously. I remember reading in one of his books that there were certain places in the world that he considered sacred above all others. One of those places was the island of Iona off the west coast of Scotland where St. Columba arrived from Ireland after fleeing the Viking invasion in 563 A.D. The island had been a special site of Celtic worship before the Christians came, and Clark said one could feel the holiness in the ground. In the cloister of the sixteenth-century cathedral on the island is a modern sculpture called "The Descent of the Spirit" by Jacques Lipchitz, who is referred to in the inscription (written in French) as a faithful Jew who made this

Ruins of the
Temple of
Apollo, Delphi,
Greece

work as a special gift. When my wife and I visited Iona I thought I felt the aura Clark described. I picked up several stones from the ground and mounted them on an old piece of wood to remind me of that strange, mystical feeling.

Another of the places that Clark identified was the site of the ancient city of Delphi in Greece, which was thought in ancient times to be the center of the world. Aside from being familiar with the immortal words that have long been associated with the oracle of Delphi, "Know thyself," my wife and I had no idea what we might see in that famous place. When we arrived, we were awed by the spectacular views. On one side of the remains of the great temple was the fabled mountain, Parnassus, where Apollo slew the serpent Python that had terrorized the people. The enormous precipice was called "shining rocks" because of the way the cliffs reflect light. To the west, there was another dramatic mountain towering some 2000 feet above sea level. And below were what seemed to be almost bottomless ravines into which the birds swooped as if the space had been created just for their pleasure. One enormously rewarding moment for us was seeing the famous bronze figure of a charioteer in the museum at Delphi, which still strikes me as one of the greatest sculptures of all time. It was discovered some years ago buried in the ground at the site

and it is not surprising to realize that the visual drama of this sacred place had inspired such a magnificent work of art. What I found especially extraordinary about that remarkable sculpture was the harmony and beauty of the folds of the charioteer's garment, which to me seemed to resemble waves in the sea and their delicate rendering inspired a particular sense of awe.

My friend Lorna Noble told me that she felt that same sense of awe when looking closely at the way the stones were laid on the Great Wall of China. I felt it again when walking in Jerusalem, seeing some of the ancient walls, and looking at the mosque on the Temple Mount. I felt it yet again in Athens, standing on the Acropolis, where I found some chips on the ground of the beautiful white stone from which the temples there are made. Later, I made a sculpture of them that is (for me) an echo of the Parthenon.

One of the most awesome sites in the world, and one that made a profound impression on me, is the ancient city of Machu Picchu, high in the mountains of Peru. Surrounded by what had long been considered impenetrable forest, the city was hidden from view for almost a thousand years. The archeologist Hiram Bingham was responsible for its discovery in 1911. In a book about his experiences, he wrote that after cutting his way through a forest he came across the remains of a stone wall. When he walked on, he saw the outline of what had once been an entire community, and it took his breath away. He realized that, "The sanctuary was lost for centuries because [it was] in the most inaccessible corner of the most inaccessible section of the central Andes . . . yet here, on this narrow ride . . . a highly civilized people, artistic, inventive, well organized, and capable of sustained endeavor, at some time in the distant past built themselves a sanctuary for the worship of the sun." Johan Reinhard, another archeologist, noted that, "beyond the undeniable majesty of the setting, there is an air of mystery about Machu Picchu that has excited the imagination of every visitor. For nowhere is it described in the chronicles of the Spanish conquest, and there were no descendants of the Incas in the area to explain the meaning of the site. The most basic questions remained unanswered: Why was it built in such an inaccessible location? Why was it abandoned? What was its meaning?" It has been said that the realm of the Incas, which came to an end in the sixteenth century when Francisco Pizarro murdered the reigning king, probably surpassed Ming China and the

Detail of the
Great Wall of
China.
Photograph by
Lorna Noble

Ottoman Empire as the largest nation on earth. Now all that is left are a few remnants of which Machu Picchu is by far the largest and most dramatic.

For years I wondered if I would ever get a chance to see Machu Picchu. Then, when I was working on a book about the work of Lika Mutal, a fine sculptor who had a home and studio in Lima, the longed-for opportunity arrived. My daughter, Dena Merriam, who was writing the text for the book, together with Nohra Haime, Lika's New York dealer, Lika herself, and her friend, Gam Klutier, took the flight to Cuzco, high in the Peruvian mountains, from which the trek to Machu Picchu would begin. We then rode first on a rickety train beside a rushing river to the valley below the legendary site, and then on a bus up the mountain, on the most winding road we had ever seen, which took us to this ancient paradise in the sky.

I thought of Pablo Neruda's poem, "The Heights of Macchu

Picchu," and his triumphant lines: "Then up the ladder of the earth I climbed/through the barbed jungle's thickets/until I reached you Machu Picchu./Tall city of stepped stone, . . ./High reef of the human dawn."

We were awestruck, stupefied, by the vastness of the panorama before us. The ancient Inca city was cut into a plateau below a higher mountain peak. On the ground were wondrous stone structures— walls, paths, stairs— that seemed more works of art than city buildings. We wondered how mere humans could have fitted the great stones together so masterfully. Every inch of the complex seemed to be part of an esthetic masterpiece. Below one could see deep ravines that enhanced the drama of the site, and it was astonishing to see clouds rising up from the surrounding chasms as if it were really a city in the sky. We even saw a rainbow *below* us as the sun lit the watery clouds, an unforgettable sight which I later recalled when reading about the Andean folk tale that a rainbow should never be stared at or pointed toward lest its spirit be bothered and retaliate by making one sick. This spirit, according to a book on Peru's customs and festivities, is so powerful that it can penetrate the wombs of young maidens and make them pregnant. One could sense the presence of the Incas in that site, even though their civilization had disappeared many centuries ago.

There was a curious echo of what I had felt at Machu Picchu in Richard Turner's book, *The Vision of Landscape in Renaissance Italy*. He observed that in fifteenth- and sixteenth-century paintings "landscape [was] not seen for itself, but as a commentary upon the human condition, as a speculation upon the tension between order and disorder in the world . . . The Renaissance artist, like Dante before him, knew that Nature had been put to shame by Art, and that the business of landscape painting was to evoke a moment of contemplation, wherein a man might discover his just relationship to an often tumultuous world." To me, Machu Picchu seemed to be a real-life evocation of exactly that kind.

In contrast to landscapes that have a symbolic or historic significance is the beauty of commonplace scenes. In Kenneth Clark's book, *Landscape Into Art*, he wrote that the poet Wordsworth and his contemporary, the painter, John Constable, "were united by their rapture in all created things." He quoted Constable as saying "I never saw an ugly thing in my life." Clark also quoted the poet Thomas Traherne

White pipes laid above ground in an Italian land-scape

"You never enjoy the world aright, till the sea itself floweth in your veins, till you are clothed with the heavens, and crowned with the stars . . . and you never enjoy the world aright, till you so love the beauty of enjoying it that you are covetous and earnest to persuade others to enjoy it."

After describing what Clark called the art of symbols and the language of decoration in late medieval mosaics, tapestries and paintings, he proceeded to what he referred to as the landscapes of fact, of fancy, of the ideal, of the natural, and of the well ordered. He wrote about the different visions of Van Eyck, DaVinci, Dürer, Brueghel, Rembrandt, Corot, Turner, Monet, Cézanne, and many others.

Looking ahead, Clark wasn't sure what the future of landscape painting might be (or even if it had a future) but he speculated that "it is possible that the emotions of excitement and awe which this terrible new universe arouses in us will find expression in some such way as the old forest fears found expression in northern art. Ultimately our expanded concept of nature may even enrich our minds with new and beautiful images." Now, some fifty years after Clark's book was published, we can look at photographs of Christo's "Running Fence" curling around the hills of California, highlighting their dramatic contours and realize that a new kind of landscape art has emerged. The stone

Right and
opposite:
Scenes in
the Catskill
Mountains,
New York

configurations of Richard Long reveal the beauty of found natural
objects. The giant curved steel structures of Richard Serra create land-
scapes that seem to come from another planet. Recently I saw a long
white pipe stretching for miles across the hills of central Italy (perhaps
in connection with a major nuclear energy plant), and that, too, looked
to me like a postmodern form of landscape art.

Artists can open our eyes to the beauties of nature in different
ways. I remember when I was an Air Force officer stationed in France
toward the end of World War II, how astonished I was to "see" Van
Gogh's blazing wheat fields, Monet's shimmering haystacks, Corot's
graceful trees, Cezanne's mountains. I had known the paintings before
I saw "the real thing," and now I was amazed to discover how much
"the real thing" looked like the paintings!

When I was assigned to a post in England, I "discovered" the landscapes that had inspired Constable and Gainsborough. In the same way, the years I spent in my family's summer home in the Catskill Mountains gave me an insight into the paintings of the Hudson River School. And there were many times driving around those Catskill Mountains when I came across colorful scenes that I thought must have inspired those painters and now inspired me.

We admire the works of landscape painters and photographers hanging in a museum gallery or reproduced in a book, but when we see at first hand the actual landscapes that inspired them, we can develop a new way of looking at nature, learn to see what the artists saw with their eyes. When we look at their paintings, a window is unconsciously opened in our minds through which we can see the world around us

Right: Horse in a landscape. Photograph by Zachary Bloomgarden

Opposite: *Adams Memorial*, by Augustus Saint-Gaudens. Rock Creek Cemetery, Washington, D.C.

the way they saw it. Thus, if we come across a scene of cows resting on a hillside with storm clouds gathering above, or a horse walking across a meadow, we may feel that we are reliving a landscape captured by a painter in the past whose work left its mark in our memory.

In his book, *Landscape as Literature*, Alfred Kazin focused on the work of American writers the way Kenneth Clark had done with European painters. Here we can experience the landscape in our imagination, guided by the descriptions of perceptive writers. Kazin began with Thomas Jefferson, who had the sharp perception of a trained naturalist as well as a keen sense of history. "The passage of the Potomac through the Blue Ridge," Jefferson wrote in one text "is, perhaps, one of the most stupendous scenes in nature . . . On your left comes up the Shenandoah . . . in the moment of their junction they rush together against the mountain, render it asunder . . . she presents to your eye, through the cleft, a small catch of smooth, blue horizon, at an infinite distance . . . inviting you . . . from the riot and tumult roaring around you, to pass through the breach and participate in the calm below."

Emerson, writing in Paris about the Jardin des Plantes, was philosophical about what he saw: "The Universe is a more amazing puzzle than ever as you glance along this bewildering series of animated forms—the hazy butterflies, the carved shells, the birds, beasts, fishes, insects, snakes—& the upheaving principle of life everywhere incipient in the very rock aping organized forms." Thoreau, in his *Walden Pond*, was more metaphorical: "A lake is the landscape's most beautiful and expressive feature. It is earth's eye; looking into which the beholder measures the depth of his own nature. The fluviatile trees next the shore are the slender eyelashes which fringe it, and the wooded hills and cliffs around are its overhanging brows." Walt Whitman saw the connection between the vastness of the universe and the most common objects of nature:

> I believe a leaf of grass is no less than the journey-work of the
> stars
> And the pismire is equally perfect, and a grain of sand, and the egg
> of the wren,
> And the tree-toad is a chef-d'oeuvre for the highest,
> And the running blackberry would adorn the parlors of heaven,
> And a mouse is miracle enough to stagger sextillions of infidels.

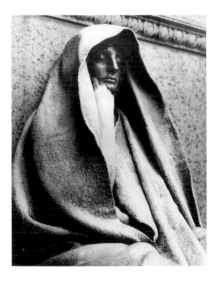

There is something in Thoreau's and Whitman's writing that may somehow echo the experiences of native Americans who have their own way of relating to the natural world. The catalogue for an exhibition organized in 1998 by the Carnegie Museum of Natural History quoted members of many tribes on their sensitivity to Nature. "We Indians think of the earth and the whole universe as a never-ending circle, and in this circle man is just another animal," said Jenny Leading Cloud, of the Lakota Sioux. "Nature is like peo-

Kerdalo,
Rennes,
France

ple, nature is alive," according to alter Sobolef, of the Tlingit tribe. Duane Bowen, a Seneca, was wistful about the loss of sensitivity to nature by the present-day members of the tribe; he said, "I really wish I could have seen the falls, this set of rapids, this gorge, the way the

ancestors saw it—just to hear the soothing roar and the quieting thunder that you hear . . . You listen to them the right way these are going to be songs—it's going to be nature singing to you."

Nature can also be designed by artists to help people cope with the traumas of life and death. One of the most moving outdoor settings in an American cemetery was created for Henry Adams's wife, Marian, after she committed suicide. Adams commissioned the leading sculptor of his day, Augustus Saint-Gaudens, to create a memorial in Rock Creek Cemetery in Washington, D.C. Saint-Gaudens designed a dramatic sculpture of a grieving figure seated in an enclosed garden that John Galsworthy called "the most beautiful thing in the United States." It is said that Adams liked to sit on the magnificent bench designed by the architect Stanford White opposite the sculpture, as his way of coming to terms with the tragic loss of his beloved wife.

Some of the grandest man-made landscapes in the world can be seen in the spectacular great houses and gardens of Great Britain. When I visited these places, I was primarily interested in their art collections, but in every instance I found the landscape astonishing. The same was true when I visited the Palace of Versailles, the Villa d'Este at Tivoli, the Boboli Gardens in Florence. In his book *The Quest for Paradise*, Ronald King traces the history of what he calls, "pleasure gardens," which he defines as "outdoor places designed by man which induce in the beholder a sense of well-being." He describes fabulous gardens dating back to ancient Egypt, Persia, Babylon, Greece, Rome, China, Japan, Aztec and Inca civilizations, and continuing throughout Europe and America to the present day.

Perhaps the grandest of all the man-made gardens I know is Kerdalo, a marvelous chateau and garden created by Peter Volkonsky near Rennes in northwestern France. Peter was in his mid-nineties and remarkably fit when my wife and I stayed at Kerdalo in connection with one of my photographic projects. The chateau has a beautiful lake, wonderful foliage, with a wide variety of trees, fields, waterfalls, grottos. The gardens are a veritable masterpiece, and they were all created by Peter as his life's work. Just having a chance to be there for a few days was a great treat, and I hoped that my photographs, some of which were published in the newspaper *Earth Times*, would be a tribute to his genius and devotion.

Imaginary landscapes provide a different kind of experience. One

painting that made a deep impression on me is of paradise by the eighteenth- and nineteenth-century English artist, John Martin. When I came across it in one of the less frequently visited sections of the Tate Gallery in London, I thought I was actually looking into a picture of heaven itself—with beautiful mountains and valleys under a magnificent sky. The painting was spellbinding, and I had difficulty tearing myself away from it. For me it echoed Dante's words in *Paradiso*:

> So great was my new vision's added strength
> That any light which ever was conceived
> Were not too bright for me to bear its fire.
> The light I saw was like a blazing river—
> A streaming radiance set between two banks
> Enamelled with the wonders of the spring.
> And from that stream proceeded living sparks
> Which set themselves in flowers on every side,
> And glowed like rubies in a golden setting—
> Until, as if o'ercome by that sweet scent,
> They plunged again into the gleaming flood,
> Whence others issued forth to take their place.

Other heavenly descriptions are more worldly; perhaps they can be called images of heaven on earth. "Lying on my back and gazing up," reads one memorable passage in W. H. Hudson's *Green Mansions*, "I felt reluctant to rise and renew my ramble. For what a roof was that above my head! Roof I call it . . . but it was no more roof-like and hindering to the soaring spirit than the higher clouds that float in changing forms and tints . . . Here Nature is unapproachable with her green, airy canopy, a sun-impregnated cloud—traversed now by a golden shaft of light falling through some break in the upper foliage, giving a strange glory to everything it touches."

In *The Water of the Wondrous Isles* by William Morris, Birdalone, the innocent, beautiful, and brave heroine who was abducted and raised by the cruel witch-wife, awoke from a deep sleep and found herself in a boat that had drifted ashore. "She stood up, and for the first minute wondered where she was, and she beheld her nakedness and knew not what it meant; then she loosened her hair, and shook its abundance all about her, and thereafter she turned her eyes on this new

*Sunflower,
Canoga Park,
California.*
Photograph by
Melissa A.
Seror

land and saw that it was fair and goodly. The flowery grass came down to the very water, and first was a fair meadowland besprinkled with big ancient trees; thence arose slopes of vineyard, and orchard and garden."

In Thomas Wolfe's *Look Homeward, Angel*, as Laura and Eugene, "blind with love and desire," walked together across a field:

The day was like gold and sapphires: here was a swift flash and sparkle, intangible and multifarious, like sunlight on roughened water, all over the land. A rich warm wind was blowing, turning all the leaves back the same way, and making mellow music through all the lute-strings of flower and grass and fruit. The wind moaned, not with the mad fiend-voice of winter in harsh boughs, but like a fruitful woman, deep-breasted, great, full of love and wisdom; like Demeter unseen and hunting through the world. A dog bayed faintly in the cove, his howl spent and broken by the wind. A cowbell tinkled gustily. In the thick wood below them

the rich notes of birds fell from their throats, straight down like nuggets. A woodpecker drummed on the dry unbarked hole of a blasted chestnut-tree. The blue gulf of the sky was spread with light massy clouds: they cruised like swift galleons, tacking across the hills before the wind, and darkening the trees below with their floating shadows.

Trees change their character through the seasons. In the spring, they are delicate and tender; in summer they are rich and full; in autumn they are like jewels against the deep blue sky; and in winter they are graceful fingers embracing the frigid air. The cycle of their lives echoes the cycle of human life. They are born in the spring, flourish in the summer, mellow in the autumn, and hibernate in winter, waiting for rebirth at another time

A talented fifteen-year-old student, Melissa A. Seror, took some remarkably sensitive nature photographs as part of her high school course. She loved the texture of one of the last sunflowers of the season in Canoga Park, California. They were in full bloom, but soon they would be gone. Her goal, like those of poets and novelists, was "to turn something people see every day into a form of art, giving them a new perspective."

Rachel Carson, who wrote her landmark book *Silent Spring* about the desolation that could be caused by the excessive use of chemicals in agriculture, wrote gloriously about the beauties of unspoiled nature. "In spring," she wrote in the beginning of her famous book, "white clouds of bloom drifted above the green fields. In autumn, oak and maple and birch set up a blaze of color that flamed and flickered across a backdrop of pines. Then foxes barked in the hills and deer silently crossed the fields, half hidden in the mists of the fall mornings." All that, she worried, would change because of the evil spell that could come over the land.

Along with other environmentalists who were inspired by her writings, Rachel Carson warned us about the need to protect and preserve nature. But she, like so many others in the course of history, taught us to love the land and the sea (her other famous book was *The Sea Around Us*) as that which nurtures our spirit as well as our lives. For it is nature that gives us a sense of oneness with creation. It fills us with a special joy for the gift of sight, and in a metaphysical sense as

well as a physical reality (for we are all made of dust and will return to dust), connects us with eternity.

With simplicity and poignancy—and a characteristic twinkle in her eye—Emily Dickinson gave her description of nature as "the gentlest mother" whose "infinite affection" extended to "the most unworthy flower":

NATURE, the gentlest mother,
Impatient of no child,
The feeblest or the waywardest,—
Her admonition mild.

In forest and the hill
By traveller is heard,
Restraining rampant squirrel
Or too impetuous bird.

How fair her conversation,
A summer afternoon,—
Her household, her assembly;
And when the sun goes down

Her voice among the aisles
Incites the timid prayer
Of the minutest cricket,
The most unworthy flower.

When all the children sleep
She turns as long away
As will suffice to light her lamps;
Then, bending from the sky,

With infinite affection
And infiniter care,
Her golden finger on her lip,
Wills silence everywhere.

CHAPTER FIVE

Forms That Shape Our Lives

IN THE EARLY 1950S, MY WIFE AND I WENT HOUSE-hunting in New York's Westchester County. We already had two children and had outgrown our four-room apartment. An uncle of mine, who was a sort of family seer, advised us to look for a house that was a little more expensive than we thought we could afford on the theory that as we grew older and made a little more money the house would still be right for us. We should try to buy a house that we could live in for the rest of our lives.

That was quite an assignment, but we dutifully went out with real estate agents every weekend and looked at dozens of houses. One Saturday morning, an agent was driving us down a street in New Rochelle. As we passed a large Spanish-style house she said, "That one is for sale, but you wouldn't be interested in it." I glanced at it in passing, and then took a second look. There was something about the house that intrigued me. I said we would like to stop and see it. The minute we walked in the door we knew it was for us. Later, the agent confessed to a mutual friend that she didn't want to show us the house because she thought it was ugly. She didn't like Spanish-style houses

and we loved them. We have now lived happily in that house for almost fifty years.

Once the house was ours, I decided that I would plan the interior myself—what kind of furniture to buy, where to put it, what colors we would paint the walls, etc. I made sketch after sketch trying to figure out what would go where, and finally, reluctantly, I gave up. All my ideas looked terrible. We decided to ask the advice of a friend of the family who was a well-known interior architect, Joseph Aronson. Joe not only designed interiors, but also furniture, and he had a small shop in which master carpenters produced chairs, tables, dressers, and couches. What he created in our home was, at least to us, a master-piece.

Joe Aronson's designs were gifts to his friends. They were cer-tainly gifts to us, and they added a special richness to our lives. This was not only because of their architectural excellence, but because they fitted, perhaps even molded in some ways, our personalities. For instance, Joe knew about my insatiable appetite for collecting books. He also knew that I couldn't possibly read every one of the thousands I was accumulating, but that just living with them would give me an indefinable pleasure. So he created beautiful wall-to-wall bookcases for almost all the rooms in the house. Joe understood that our library would continue to grow as long as we lived. For our living room he designed bookcases with shelves that slanted outward, designed so that they could be converted to regular shelves as our library grew. This gave us an opportunity to display special pages of newly acquired books before putting them in their allotted places. I eventually filled those living room bookcases with about 2,500 volumes on individual artists. Cases in another room in our house were filled with books on poetry. Still others were devoted to photography, biographies, novels, and so on. I have enjoyed looking at those books every day—both the ones that I have read and those I have only skimmed, with gratitude to Joe for making it all possible.

Laura and I also are collectors of sculpture, and Joe helped us place new acquisitions in a natural and organic way around our home. Once when we acquired a large Henry Moore sculpture, Joe became angry with us. There was no way, he insisted, to place a sculpture of that size in the house without destroying the space. Joe's wife, Henri (for Henrietta), told us quietly not to be upset. She promised that if we

would let Joe sleep on it, he would find a solution. And so he did. He came up with the idea of breaking the wall between the living and dining rooms, placing the Moore sculpture there, and filling in the remaining space with a *shoji* screen. The idea worked magnificently. Since Joe solved the problem, we have looked at the great Moore sculpture day after day, seeing it from all angles, enjoying its magnificent forms from both rooms, and marveling at all its wonderful details.

A collector friend of mine, Fred Wiseman, once told me that he moved paintings and sculptures in his home to different locations every couple of months. His theory was that if they stayed in the same place, he would take them for granted and stop paying attention to them. Changing their locations made him look at them with a fresh eye. I understand how he felt, and I change some things in my home from time to time. For instance, ever since I was a teenager I have mounted postcard reproductions of paintings and sculptures on the back of the closet door in my bedroom. I look at them every day when I get dressed in the morning, and the images thus have time to sink into my psyche. I always buy postcard reproductions when I go to museums, and periodically I change the display in my closet, thus continuously expanding my esthetic horizons. I mentioned earlier my visit to Kenneth Clark's home in Saltwood; I also visited his apartment in London, and there, on a shelf in his living room, I saw a selection of postcard reproductions which I'm sure he changed from time to time. But I feel differently about major works of art in my home. I consider those as being similar to the permanent collection in a museum. I like to choose what I think is the *right* place for individual drawings, paintings, and sculptures, and once they are there, they become an integral part of my life.

When I was young, my mother would periodically change the position of the furniture in our home, and we would enjoy the new arrangement as a fresh experience. But Joe Aronson's furniture pieces were works of art in themselves, and their beauty as well as their function depended on where they were placed. Indeed, he designed them for the spaces where they were placed, and to move them would destroy their integrity. They were, in effect, site-specific. Their forms, lines, textures, and materials were simple but elegant, and their interrelationship is what made our rooms work for us. Joe seemed to have an unerring eye and a keen sensitivity for how people wanted to live. He also had an encyclopedic knowledge of the history of furniture. In 1938

he had published a monumental *Encyclopedia of Furniture* (with several revisions over the next twenty-five years) that included some two thousand illustrations. Joe explained in his foreword to the third edition that the encyclopedia covered the mainstream of furniture design as it "flowed from Italy to France with the spreading Renaissance, thence all over Europe [and eventually to America] to merge with or obliterate the native arts peculiar to isolated locales." Characteristically, Joe offered no esthetic judgment; he only sought to illustrate "those forms and styles that in their time gave satisfaction to their makers and users." Joe never claimed that the designs of any one period or artist were "better" than others, he simply pointed out that "there is useful and philosophic pleasure in recognizing [individual design] as a key to the manners, mores, and means of other times and places." I always thought that his encyclopedic knowledge helped him to create his own furniture.

Toward the end of his life Joe spent a good deal of his time living in London, which both he and Henri loved. He would walk alone for hours through the streets studying the shapes and details of buildings as if he were collecting visual information for his omnivorous mind. He seemed to have sharpened his eye to such a fine point that he could see and store in his memory things that were invisible to, or at least unnoticed by, others. That he no longer had any intention of putting this knowledge to use or even telling others about his observations, and that the discoveries he was making were only for his own pleasure did not matter. Just seeing them enriched his life immeasurably.

I have a feeling that others who have spent years looking at and admiring fine works of architecture have had the same experience; they find that they appreciate what they see all the more intensely as they grow older. Certainly that has happened with me. I find today that I have grown increasingly sensitive to combinations of form, color, light and shadow; I have the sense that I am discovering masterpieces of composition that I would not have been aware of in the past. Seeing masterpieces every day is not a bad way to live!

Shortly after Joe died I visited the United Nations International School (UNIS) in New York, and I wished Joe could have been there with me. Although I don't think he ever designed any interiors for schools, he would have been delighted with the openness and warmth of the spaces of UNIS. Designed by Max Abramowitz, the school was

Playground at
the United
Nations
International
School (UNIS)
in New York

a place in which children from over one hundred countries could meet with students from the metropolitan New York area to study and play together. There was a lightness and airiness to all the spaces; the library, gymnasium, and auditorium were beautifully designed with the most up-to-date equipment; even the elevators and staircases were large and cheerful. The environment encouraged creativity, and I was struck by the excellent quality of the children's paintings, which filled all the halls and classrooms. Joseph Blaney, the director, told me that it was the policy of the school to have at least one painting by every student exhibited on the walls every semester. It was a nurturing atmosphere for children, and one could sense that the visual impact of the architecture had a direct impact on the quality and experience of teaching and learning.

One of Joe Aronson's favorite books was *Architecture in Space* by

Bruno Zevi, dedicated "To all my friends in the movement for organic architecture." Zevi believed that the average reader, leafing through books on the esthetics and criticism of architecture, must inevitably be horrified by the vagueness of the terms that are used. He wanted his readers to think of architecture "like a great hollowed-out sculpture which man enters and apprehends by moving about within it." He described what he called physio- psychological aspects of architecture, by which he meant the feelings evoked by different geometric forms— the horizontal line, the curved line, the cube, and so on. He also defined unity as the single idea represented in a work; and gave similar definitions to such concepts as symmetry, balance, emphasis, contrast, proportion, scale, character, truth, propriety, urbanity, style. Underlying all of these was *space* and how it affected the lives of people moving within it.

Those definitions came to mind recently when I visited Misono, the headquarters of an organization called Shinji Shumeikai—or Shumei—in the Shigaraki Hills, near Kyoto, Japan. *Shigaraki* is a Sanskrit word meaning a place to gather the hearts of the people from all over the world, which turned out to be a prescient name for this site. *Shinji Shumeikai* means brilliant or divine light, which I take to be a metaphor for insight or enlightenment. The organization is a cultural, environmental, and spiritual fellowship with members all over the world. As an expression of its beliefs, the founders created one of the world's great art collections of ancient sculpture and built the Miho Museum designed by I. M. Pei on a magnificent hilltop site. The founders also developed initiatives to encourage the practice of natural agriculture as a means of preserving the earth's environment. Today, the leaders of the organization hope that these activities will help bring enlightenment and peace to the world.

When I visited Misono the first architectural form I saw were wide, horizontal stone stairs rising from the path below to a grand plaza above. I thought of Zevi's observation that the horizontal line in architecture stood for "the rational, the intellectual, the immanent." Above the stairs were eight striking vertical sculptures by the Japanese artist, Masayuki Nagare. According to Zevi, the vertical line is "a symbol of the infinite, of ecstasy, of emotion." At the end of the plaza was a great bell tower called "The Joy of Angels," designed by I. M. Pei, with fifty carillons that play Japanese folk music three times a day; its

extraordinary graceful lines curve outward as the tower rises into the air. Zevi's words for curved lines in architecture were "flexibility and decorative values." The large assembly hall designed by the leading Japanese architect Minoru Yamasaki, seats as many as ten thousand people, also featured strong curving lines. Nearby, I walked on a path through a garden and came to an opening with a grand waterfall on one side and a stone wall with abstract relief sculptures by Nagare on the other. In the sculpture were spiral forms, which Zevi called "symbols of ascension, detachment, of being freed from earthly matters." There were also circles, which according to Zevi convey "a sense of equilibrium, of mastery, of control over the whole of life." Another sculpture by Nagare opposite the fountain is in the form of an arch that Zevi believed "represents integrity, and gives the observer a feeling of certainty."

After spending some time at this site, I went to the top of a neighboring hill to visit I. M. Pei's Miho Museum. I approached the museum through a tunnel designed by Pei, and the outer curve of the structure seemed elliptical in shape; Zevi saw the ellipse as "a form that never permits the eye to rest, keeps it moving and unquiet." I emerged from the tunnel and crossed a bridge over a valley to enter the museum itself which is a complex arrangement of forms that can best be described by Zevi's phrase, "interpenetration of geometric forms . . . the symbol of dynamism and continuous movement."

Thus, in a remarkable way the entire complex utilized a wide variety of architectural forms to create on two hilltops near Kyoto, structures that tell something about Shinji Shumeikai's ideals. "Rational, immanent, moving, dynamic, integrity"—those words are implicit in the architecture and are also relevant to the fellowship that inspired it.

There was another aspect of the tunnel and bridge that was intriguing. I. M. Pei told me that as a child he had read a fourth-century legend called "Peach Blossom Spring" by Tao Yuan Ming, about a fisherman wandering through the countryside. One day, as the fisherman followed the course of a stream, he came upon a grove of blossoming peach trees that lined either bank for hundreds of paces. No tree of any other kind stood among them. The grove ended at a spring, and on the side of a hill was a small opening that revealed a gleam of light. The fisherman entered the opening, made his way through a small passage, and emerged into the open light of day. Imposing buildings stood in

Entrance to
Miho Museum,
Japan

front of him among rich fields. It was like finding heaven on earth. Pei never forgot that story, and he was delighted to know that Mrs. Koyama, the then president of Shinji Shumeikai, knew it as well. And so they created their modern Peach Blossom Spring by designing a beautiful tunnel and a bridge that led to the Miho Museum.

There was an aura of perfection everywhere I looked. Even the top of the hill where the museum was built was preserved in its pristine state. No road had been cut through the forest to disturb its natural contour; one could only enter by way of the tunnel and the bridge. In the different galleries of the museum, which was built into the hill (80 percent of it is underground) were great works of art, some dating back to the third millennium B.C., and were from such diverse cultures as ancient Egypt, Greece, Rome, Tibet, China, Japan. The displays and lighting were exquisite. In one courtyard of the museum there was a beautiful Japanese garden with marvelously shaped natural stones on pure white gravel. Through windows in the back of the museum I could look out on lush greenery, with branches of wonderfully gnarled trees reaching into the sky.

The Miho Museum was one of three great architectural projects that were completed in 1997. The second was the Guggenheim

Museum in Bilbao, Spain, and the third was the Getty Center in Los Angeles. All three were examples of how the forms of buildings can shape the experiences of those who visit them.

The Guggenheim/Bilbao Museum, designed by Frank Gehry, has been described as one of the most remarkable buildings of the twentieth century. When the *New York Times* magazine section published a cover story about it, the headline stated "Miracles still occur." A visitor to the museum can see why.

Bilbao is an undistinguished industrial city in the center of the Basque country of northern Spain. It has long had a municipal art museum with many treasures that have been collected by the community over the years. But the city government decided some years ago to launch a campaign to give the community worldwide distinction. This would encourage a lively tourist trade, which could be economically beneficial, and also attract investments for this growing and ambitious city. To accomplish this objective it decided to invest $100 million in a new museum that would be run by New York's Guggenheim Museum, and that would also be an outstanding work of architecture. Frank Gehry, the architect chosen for the project, created a design that shook the world.

When the visitor approaches the museum through the city streets, its swooping titanium roofs glisten against the sky like a great bird about to take wing. A giant sculpture of a dog by Jeff Koons stands menacingly in front, adding a startling note to the scene. When one stands in front of it, however, the complex seems like a fairyland. Perhaps it would be less startling in another environment, but with the staid buildings of Bilbao as a surrounding, it takes one's breath away. Entering the museum and looking in all directions, the visitor cannot help marveling at the imagination of the architect who created these swirling forms. Not only are they magnificent in themselves, but works of art beneath them seem to be transformed by this fantastic environment. The building does as much for the art as the art does for the building. Together they have transformed the city of Bilbao from an unimpressive urban center into one of the world's most exciting places to view contemporary works of art. It has also made the citizens of Bilbao, as well as the Basque community, proud of its history, as well as of this new manifestation of its vitality and dynamism.

The Getty Center is another kind of story. The J. Paul Getty

Trust is one of the largest foundations in the world (almost as big as the Ford Foundation), and by far the largest in the field of the arts. Under the leadership of its first president, Harold Williams, who had had a distinguished career in business, academics, and government, seven distinct divisions of the foundation were created: the J. Paul Getty Museum, the Getty Research Institute for the Arts and Humanities, the Getty Conservation Institute, the Getty Information Institute, the Getty Education Institute for the Arts, the Getty Grant Program, the Getty Leadership Institute for Museum Management. These are run somewhat autonomously, and there is still very little public understanding of the overall program. The division that had the highest visibility was the Getty Museum; the others were known only to specialists in their fields.

After much reflection and planning, the decision was made to bring all of these operations into one place that would be called the Getty Center. Land was acquired in a beautiful location in the Santa Monica hills, and a renowned architect, Richard Meier, was selected to design the center. In the fall of 1997, the new cluster of buildings was completed—at a cost of approximately one billion dollars—and it was opened to the public with considerable excitement.

Riding the specially designed tram up to the Getty Center is a unique experience. Seeing the gleaming white marble structures come into view is reminiscent of mounting the enormous rocky elevation in Athens on which the Acropolis is built. It is truly a grand sight, with a spectacular view of the city of Los Angeles below. Walking around the pathways and gardens and entering the various buildings, the visitor cannot help feeling an air of permanence about the complex. It is a twentieth-century classic, seemingly built to endure forever as a major work of architecture. Much larger and more elaborate (although not more beautiful) than either the Miho or the Guggenheim/Bilbao museums, it creates for visitors a truly overwhelming experience.

In 1977, twenty years before these ambitious projects were opened to worldwide public acclaim, a quiet building with the cumbersome name of the Yale Center for British Art made its appearance in New Haven, Connecticut. The Center was the last building designed by the great architect, Louis Kahn. It was created to house the Paul Mellon collection of British art, which the philanthropist had given to Yale, and also to provide a space in which to mount exhibitions that

had some connection with Great Britain. My own work has been exhibited in the museum. The first of these was a show of a series of paintings of mine inspired by T. S. Eliot's poem, *Four Quartets.* The other was of a selection of photographs that I had taken of Henry Moore's sculptures in public places around the world. Working on those exhibitions involved many visits to the museum, and I got to know it well. If one can fall in love with a building, that is what happened to me with this superb example of Louis Kahn's architecture.

The Yale Center is very different from the Getty, the Guggenheim/Bilbao and the Miho, just as Louis Kahn was different from Pei, Gehry, and Meier. These three welcomed the international fanfare that greeted their new achievements. Kahn did not expect that kind of reception, and probably would not have handled it well if it had occurred. He had been first a philosopher and a teacher, and did not emerge as a working architect until after the age of fifty.

Kahn spoke about architecture as a mystic. "When personal feeling transcends into Religion (not a religion but the essence of religion)," he once said, "and Thought leads to Philosophy, the mind opens to realization. Realization is the merging of Thought and Feeling at the closest rapport of the mind with the Psyche, the source of what a thing wants to be . . . A great building, in my opinion, must begin with the unmeasurable . . . what is unmeasurable is the psychic spirit. The psyche is expressed by feeling and also thought and I believe will always be unmeasurable. I sense that the psychic Existence Will calls on nature to make what it wants to be. I think a rose wants to be a rose."

It took a certain kind of client to be willing to work with Louis Kahn. He was a man with powerful beliefs, and neither money nor popular appeal were his concern. As the architectural historian and theorist Vincent Scully put it, Kahn's designs were not for the fainthearted; he "requires wise and courageous clients who are willing to forego the gloss of superficial perfection in order to take part in a sustained and demanding process of which they may one day be proud." Scully quotes Kahn as saying "The right thing done badly is always greater than the wrong thing well done." Kahn did not pretend to be a master, according to Scully, and did not want apprentices. People worked for him "like men in a grubby office on a busy corner in the heart of Philadelphia."

In Tom Wolfe's amusing book on twentieth-century architects,

From Bauhaus to Our House, Kahn was mentioned only briefly. Wolfe described him as "not much to look at . . . He was short. He had wispy reddish-white hair that stuck out this way and that. His face was badly scarred as the result of a childhood accident. He wore wrinkled shirts and black suits. The backs of his sleeves were shiny. He always had a little cigar of unfortunate hue in his mouth. His tie was always loose."

I once recommended Louis Kahn as the architect of a new library that was being planned for the Jewish Theological Seminary in New York. Kahn was intrigued with the project, but he was vetoed by some of my conservative fellow trustees who were worried—with good reason—that he would have gone over budget. I was disappointed, since I thought Kahn was the epitome of what the Roman author Vitruvius thought was the ideal architect: a man who was philosophical, unassuming, high-minded, just, honest, without pretense or avarice, and without concern for honors or riches.

The first director of the Yale Center for British Art, Jules David Prown, recommended Louis Kahn, whom he believed to be the greatest living architect, as the designer of the building. In his initial memorandum, Prown wrote that "the building should not awe or overwhelm by its monumentality. It should welcome the visitor, arouse his interest and curiosity, evoke a desire to enter." The result, according to Prown's successor, Duncan Robinson, was a miraculous building with a special alchemy, a "combination of shrine, temple and palace."

There is something organic about the building. The richness of the materials and the felicitous way they relate to one another makes the building seem like an organic whole. The building almost seems alive. Although it seems simple and relatively unobtrusive, it has a mysterious quality about it. "On a dull day" Robinson wrote about the exterior of the building, "the burnished steel panels are soft and light-absorbent, like bales of good gray English cloth. The building is solemn. In bright light the windows in the facades shine with reflections; they serve as mirrors held to the sky, the trees, and the buildings opposite. It smiles." Robinson believed the building had "an architectural integrity which has been achieved all too rarely in the western tradition since Greek colonists raised the temples of Paestum on the Italian peninsula . . . Spaces and textures alike are softened into seemingly endless vistas of visual pleasure."

Light is a key word in describing the building. "A plan of a build-

ing should be read like a harmony of spaces in light," Kahn once wrote. "Even a space intended to be dark should have just enough light from some mysterious opening to tell us how dark it really is." Elsewhere he wrote, "I sense Light as the giver of all presences . . . What is made by Light casts a shadow, and the shadow belongs to Light." The marvelous lights and shadows thrown on the walls of the atrium when the sun shines through the glass ceiling are like revelations of an unknown world. *Detail*, another key word, is evident in beams, handrails, cylindrical steel ducts, light shades, and in such features as the rectangular white-oak panels that are flush with their frames, separated only by means of vertical and horizontal grooves between the elements. The wood finish is that of cabinetmaking rather than carpentry. In the galleries, walls are covered with unbleached linen, complementing the warm tone of the other furnishings, the undyed woolen carpets, and the trim of untreated white oak. Doors everywhere, including those for elevators, are simple and understated, accented by modest handles. *Honesty* is a third word that can be applied to the building. It is apparent in the lack of pretension throughout. The building is what it is,

unself-consciously. Everything there is made to enhance the visitor's experience. No element is designed to be spectacular. Nothing is extraneous. Even the director's office does not have a sign outside to disturb the geometry of the space. Balconies on each floor create a sense of openness as one looks through the spaces to other parts of the building. When the eye discovers something in a remote and almost hidden corner you are surprised to see how carefully it has been designed. One of the most beautiful parts of the building is the staircase, which is hidden behind closed doors. You have a feeling that it wasn't meant to be beautiful, it just is. Kahn once said, "To make a thing deliberately beautiful is a dastardly act." His final masterpiece is a testament to his faith in an architecture that serves a building's "psychic Existence Will," helping it become what it wants to be.

Kahn's life ended on a tragic note. He was spending a good deal of time on his massive Abbasabad city redevelopment project in Tehran, Iran, while also working at Yale. Returning to the United States after one of his trips abroad, he landed at Kennedy Airport and went to Penn Station in New York to take a train to Philadelphia, where he

Cathedral,
Barcelona

lived. Before boarding the train he stopped in the men's room, where he had a heart attack and died. A thief, seeing him on the floor, emptied his pockets and ran away. When the police discovered the body, they found no identification and had to send it to the city morgue. Kahn's wife was worried when he didn't show up as scheduled, but assumed there had been a delay. Eventually she notified the police and not until three days later did she identify Kahn's body in the morgue in New York.

Such disasters can happen to anyone. But somehow the story of Louis Kahn's death seems to provide a special commentary on his life. His consuming passion for his work apparently overwhelmed his concern about himself. It almost seems symbolic that he lost his personal identity in the midst of some of his most enduring contributions. It has been said that a great man seeks recognition for his work rather than himself, and although Louis Kahn's name will long be remembered, the light he brought to mankind through his brilliant designs is his legacy, whether or not he is personally identified with it.

Temple of the Sagrada Familia (detail of the towers), designed by Antonio Gaudí, Barcelona, Spain

It's not surprising that museums are among the greatest buildings of our time. The places are where people come to see the treasures of our civilization. They come by the millions to see significant works of art. A few centuries ago, those experiences were reserved for princes, popes, and emperors. Now the houses of these men—or their government—have become museums for us—the Palazzo Vecchio, the Vatican Palace, the Doge's Palace, the Topkapi Palace, Versailles, Windsor Castle. They overwhelm us with the manifestations of what seems to have been virtually unlimited wealth. We are in awe when we walk through their enormous rooms, look at the exquisite furnishings, absorb the qualities of great works of art. We ask ourselves: Did people really live in these magnificent edifices? What could their lives have been like? Was intimacy, humor, playfulness, relaxation unknown in these environs? When we visit a museum today we may spend an hour or two, but these people lived in their palaces for a lifetime. It is hard for us to imagine the kind of lives they led.

It is different, however, when we think of the cathedrals, churches, temples, and mosques that shaped the lives of our ancestors. We can imagine the visionary experiences of those who designed and built them. "The Archangel loved heights," wrote Henry Adams, in describ-

Right and
opposite:
Watts Tower
by Simon
Rodia, Los
Angeles,
California

ing the eleventh-century Mont St. Michel in northern France. "Standing
on the summit of the tower that crowned his church, wings upspread,
sword uplifted, the devil crawling beneath, and the cock, symbol of
eternal vigilance, perched on his mail foot, Saint Michael held a place
of his own in Heaven and on earth . . . The church stands high on the
summit of this granite rock . . . the eye plunges down, two hundred and
thirty-five feet, to the wide sands or the wider ocean, as the tides
recede or advance, under an infinite sky, over a restless sea."

Mont St. Michel is surely one of the most dramatic religious sites
in the world. Adams's description of its many details reads like a great
work of fiction. And yet each of the dozens—could one say hun-
dreds?—of great churches and cathedrals that can be seen in many
countries has its own special character. I have been enthralled by the
many I have seen throughout Europe, and I know there are many more
that I have not seen. Henry Adams may have been right when he
described the smaller of the spires of Chartres as "the most perfect
piece of architecture in the world." Others have written rhapsodically
about other cathedrals—in France, England, Italy, and Germany. One

spectacular sight that dazzled me not long ago was the great Gothic cathedral in Barcelona, lit up at night like a great crown filled with beautiful jewels.

Barcelona offers another spiritual and architectural feast for visitors: the work of Antonio Gaudí. Not only is his famous Temple of the Sagrada Familia a unique work of religious architecture, even in its incomplete state, but all of Gaudí's buildings embody something mystical. This includes the apartment houses, the private homes, and the fantastic Guell Park and estate. All of these feature Gaudí's symphony of curves. "There are no straight lines in nature," he once observed, and nature was his guide. He loved flowers, and they were the inspiration for his glorious colors in ceramics and stained glass that he incorporated in his buildings, including broken bottles, crockery, stones, naked rubblework, and sometimes graffiti. The result is a world of fantasy and wonder.

In one of those strange coincidences that occur in the course of history, while Gaudí was designing his extraordinary structures in Barcelona, an Italian immigrant construction worker, Simon Rodia,

started to build what came to be known as the Watts Towers in the slums of Los Angeles. Rodia was twenty-seven years younger than Gaudí (Gaudí was born in 1852 and Rodia in 1879), and while the similarity of their work has been noted by observers, there is no published evidence that Rodia knew about Gaudí's work. It has generally been assumed that Rodia was self-taught. He decorated his structures with found objects, including broken glass, seashells, pottery, tile, and ceramics, and they exhibit a spiritual quality akin to Gaudí's. The tallest of his towers stands more than ninety-nine feet high and contains the longest reinforced concrete column in the world. The monument also features a gazebo with a circular bench, three birdbaths, a center column, and a spire reaching a height of thirty-eight feet. Rodia worked for thirty-three years alone to build his towers, without the benefit of machine equipment, scaffolding, bolts, rivets, welds, or designs. The Watts Towers are described as the largest work of art created by a single person in the United States. In 1954, at the age of seventy-four, Rodia retired and moved away, deeding his Towers to a neighbor. Today they are the property of the City of Los Angeles, and have been declared a national historic landmark.

The Byzantine churches in Athens and Istanbul; the monasteries on the holy Mount Athos; the mosques in Cairo, Rabat, and Jerusalem; and the temples in Delhi, Kyoto, and Bangkok are all very different from the cathedrals of the west. But they, too, are examples of the highest architectural achievement of their eras and their cultures. One may or may not feel inspired to pray in their presence, but one cannot fail to be awed by the sight of exquisite forms created by people who were totally devoted to their religion and their art.

A friend of mine once pointed out that only the Jews do not have great temples that are considered to be among the wonders of the world. Their most holy place is a wall—the eastern wall of the Temple in Jerusalem that was destroyed over two thousand years ago. While other religions have the benefit of magnificent edifices to inspire them, the Jews only have a simple stone wall as their sacred place. But those stones have developed a character unlike any other, perhaps because of all the tears that have flowed over them and the fervor with which the devoted have prayed before those rough surfaces. Looking at those stones can evoke as powerful a sense of spirituality as the loftiest Gothic cathedral. Perhaps it is more what the mind remembers than

Woman praying at the Western Wall, Jerusalem, Israel.
Photograph © Bill Aron. All rights reserved

what the eye sees, but in the presence of such powerful and palpable symbols, the two forms of experience come together to create an unforgettable and heart-wrenching whole.

CHAPTER SIX

Things, Common and Uncommon

SOME YEARS AGO I HAD OCCASION TO VISIT THE Kohler plant in Kohler, Wisconsin. The company happened to be a client of the public relations firm where I work, and I was there for a meeting with its management. When going through the plant I looked with something of a curious eye at the hundreds of porcelain bathroom products placed neatly on shelves. Seeing them in this unaccustomed way gave a new perspective on what had heretofore been common objects that I had paid little or no attention to. Nearby there was a display of toilet bowls stacked high, with a sign "The Great Wall of China." For the first time I wondered what it must have been like before toilets existed and how they came to be the way they are today.

What happened on that visit was the beginning of a mental process by which I could look at familiar objects with a new perspective. This has enabled me to make surprising discoveries in a long stream of objects that I have previously taken for granted. I *examine* these objects esthetically rather than just use them functionally. To be able to describe the experience, I recently made some notes about what I could see while looking around my bathroom. I had never before paid

attention to the shape of the soap dish on the sink, nor the porcelain toothbrush holder, nor the electric toothbrush. On a shelf over the sink I examined the half-dozen bottles of lotion and perfume with differently shaped glass containers and spray heads. Inside the medicine cabinet there were about twenty-five different jars of medicines, as well as vit- amins, facial cream, toothpaste, hairbrushes, combs, and razors. Over the bathtub there was a clothesline with about a dozen plastic pins in different colors. All of these were designed by people who chose forms, colors, patterns they thought would appeal to customers like my wife and me and no doubt millions of others. Yet I had never been con- sciously aware of their design elements as a quality separate and dis- tinct from (although not unrelated to) their utility.

Then I went into other rooms in the house, and my list of com- monplace objects that deserved to be looked at in esthetic terms grew longer. In our bedroom there were clothes closets with hangers, shoe racks, and peg boards; in mine there were suits, jackets, trousers, and so on, and in my wife's at least twice as many clothes. In the room itself there was common bedroom furniture but also souvenirs of our travels, books, and works of art, almost all with stories to tell. In the dining room and kitchen, I thought about all the efforts that had been made to design appliances, cutlery, dinnerware, glassware, food packages, etc.

The poet Pablo Neruda wrote a book of poems which he called *Odes to Common Things*. It included odes to such objects as a bed, a chair, a bar of soap, a pair of scissors, a spoon, a plate, an orange, a dog, a cat, a tomato. His opening poem was called simply "Ode to Things." It begins:

> I have a crazy
> crazy love of things.
> I like pliers,
> and scissors.
> I love
> cups,
> rings,
> and bowls—
> not to speak, of course,
> of hats.
> I love all things,

not just
the grandest,
also the
infinite-
ly
small—
thimbles,
spurs,
plates,
and flower vases.

Oh yes,
the planet
is sublime!
It's full of
pipes
weaving
Hand-held
through tobacco smoke,
and keys
and salt shakers—
everything,
I mean.
that is made
by the hand of man, every little thing:
shapely shoes,
and fabric,
and each new
bloodless birth
of gold,
eyeglasses,
carpenter's nails,
brushes,
clock, compasses,
coins, and the so-soft
softness of chairs . . .

The poem ends with an attempt to explain why all of these things have made such an impact on the poet:

O irrevocable
river
of things:
no one can say
that I loved
only
fish,
or the plants of the jungle and the field,
that I loved
only
those things that leap and climb, desire, and survive.
It's not true:
many things conspired
to tell me the whole story.
Not only did they touch me,
Or my hand touched them:
They were
so close
that they were a part
of my being,
they were so alive with me
that they lived half my life
and will die half my death.

One of Neruda's points, I think, is that everything we look at has a unique shape, color, and texture—as well as function. Although we rarely pay attention to the design of utilitarian objects, if we look at them with a sensitive eye we can appreciate their esthetic qualities as well as their functions.

When I was noting the objects in my bathroom, I became aware for the first time that my electric toothbrush was white with two upright blue stripes of rubber to hold the handle. The button to turn the toothbrush on and off was made of the same blue rubber. There was even a matching blue section of the brush itself, and a colored ring of rubber at the base of the brush handle. This was a far more careful-

Untitled, a sculpture by Richard Stankiewicz

ly thought-out design than I had ever imagined. The same was true of my plastic throwaway razor with its graceful bend that made it seem as if the head was eagerly reaching out to do its job. If either my toothbrush or razor had been mounted on a base, it might well have qualified as a sculpture. Had they been presented as works of art, I would have seen something more than object, something deeper in the way forms can take on a life of their own and create enduring values. "Rightly viewed," Thomas Carlyle wrote in *Sartor Resartus*, "no meanest object is insignificant; all objects are as windows, through which the philosophic eye looks into Infinitude itself."

Teaching us to look at such commonplace objects with a "creative" eye was the subject of what the Museum of Modern Art called "The Object Transformed" in a 1966 exhibition. Among the works exhibited was a book with pins, knife, and a razor, put together by Lucas Samaras; a flat iron with tacks on the bottom by Man Ray; a flannel dress with spaghetti glued to it by Kusama; and a bed with paint on the pillow and quilt by Robert Rauschenberg. Transforming

Old door, Basel, Switzerland

ordinary objects into works of art prompts one to think of how they changed people's lives when they came into being, and what we would do if we didn't have them.

One of the pioneers in the use of spare parts and other objects as elements of sculpture was Richard Stankiewicz. Although he used ordinary things that one would not usually think of as aesthetically interesting, he assembled them to create forms of his own invention that always had a remarkable quality of elegance.

Another remarkable artist who used real objects to make fantastic sculptures was the Swiss sculptor Jean Tinguely. He added motors to his structures and made many parts of them move in different ways. One writer called his work a "paroxysm of junk in motion." Tinguely created a famous machine that destroyed itself and called it "auto-destructive and auto-creative" art. But his more enduring contribution was in large works that turn on themselves, spurt water, and move around a large area in strange ways—all made of machine parts. The Swiss are very proud of Tinguely's place in twentieth-century art, and

there are enormous works by him in public squares in Lausanne and Basel. There is a most impressive museum in Basel for Tinguely's work, which also includes some giant sculptures by his wife, Niki de Saint-Phalle.

Seeing the work of innovative artists like Stankiewicz and Tinguely challenges one to find esthetic qualities in things so mundane that we never think to look at them. After visiting the Tinguely Museum, I wandered around Basel and found myself entranced by an old door on which the lock, handle, and hanging chain, together with the random composition of the peeling paint (on which the name "Lorna" somehow appeared), could be looked at as a work of art. Cracked wooden beams fitted together on a nearby wall were equally fascinating. As I crossed one of the bridges over the Rhine River, my eye was drawn to the strong diagonals of the iron girders underneath. Elsewhere, on the wall of a building, a round knob with a horizontal line above it and a vertical arrow above that, pointing to an upstairs apartment, produced a superb abstract composition. Still later, I was struck by the felicitous relationship of forms in a lithographer's press with a large wheel.

The social theorist Marshall McLuhan analyzed the Greek myth of Narcissus for clues to the nature of the process by which people have been impelled to produce an ever-increasing multiplicity of objects over the centuries. He suggested that the common interpretation of the myth that Narcissus fell in love with his image was wrong. Instead, according to McLuhan, Narcissus mistook his own reflection in the water for another person. "This extension of himself by mirror," wrote McLuhan, "numbed his perceptions until he became the servo-mechanism of his own extended or repeated image." McLuhan's theory was that the spur to invention is the "amputation" of a function from one's body and the extension of it in a new form. Thus, for example, we amputate the function of motion from our bodies and invent the wheel as an efficient way of moving from place to place more rapidly and tirelessly. Thus the wheel becomes an extension of us. "In the electric age," he believed, "we wear all mankind as our skin."

Many objects that we rarely pay attention to because they are so commonplace changed the course of history when they were invented. For instance, the historian Lynn White described the feudal system as a social extension of the stirrup, which first appeared in the West in

the eighth century A.D. To mount a knight in full armor, White explained, required the help of ten or more peasants. This led not only to new designs for armor and ways to make the horse a more effective carrier for humans, but to major social changes. At the same time, the invention of the horse collar and the harness had increased the speed and endurance of the horse and eventually led to the discovery of the wheel. This was a short step away from the development of the four-wheel wagon to carry heavy loads, and the movement of peasants to living quarters in towns from which they now could travel each day to their fields. And so as a result of these inventions the whole pattern of daily life was changed. One can visualize the evolution of civilization as a consequence of new objects being invented and providing ever-greater conveniences for mankind. Whenever a new kind of object came into being, it was a subject for design by skilled individuals whose work expanded the visual experiences of humanity.

Such changes occur not only in the mainstream of civilization, but in lesser known and remote regions of the world. In Kitawa, an island off the coast of New Guinea, natives who live in a Neolithic environment without a written language have a highly sophisticated design tradition. An Italian anthropologist, Giancarlo M. G. Scoditti, spent years documenting the aesthetic qualities and symbolism of the graphic designs carved on the prows of wood canoes. Examples of these decorative elements can be found in New York's American Museum of Natural History and in the Brooklyn Museum. "I will never forget the first time I witnessed the cutting of a canoe," Scoditti told Alexander Stille, a writer for *The New Yorker.* "It was perhaps the most moving thing I had ever seen." The carvers, according to Stille, are something like a secret society, with a special initiation, strict dietary rules, and many years of hard training. Scoditti said that the undisputed master carver, Towitara, reminded him of the renowned art historian Ernst Gombrich. "In both," Scoditti said, "I felt I touched real wisdom."

The tradition of carving original designs for utilitarian objects is found in many cultures. Thus, in the National Museum of Peasant Art in Wales, there is a collection of "love spoons" with handsomely designed decorative handles that were intended to visually express the amorous sentiments of their artists. In different African cultures, sculptors created figures for such common objects as bowls and looms, presumably for women to look at and enjoy while working.

Baule spinning
wheel decora-
tion, Africa

Perceptions in such cultures are often extraordinarily sharp and insightful, not only visually but verbally, as well. Marshall McLuhan referred to a native West African who saw books on a missionary's bookshelf and came to understand that "the marks on the pages were *trapped words.*" He was amazed that anyone could learn to decipher the symbols and turn the trapped words loose again into speech. That is a remarkably vivid way to describe how the written word works as a means of communication.

Trapped words would not be a bad way to describe the signs we see all around us in urban settings. Julian Lewis Watkins, an advertising copywriter who published a book in 1949 on what he considered to be the one hundred best advertisements of all time, wrote: "As I sit here in my office . . . I can see across the rooftops some sixty advertisements . . . They all look good to me! . . . These familiar clarions of commerce are actually the last strong line of free enterprise."

I find Watkins's enthusiasm for what he saw out of his window rather amusing, since when I was working on the book *Our New York* with Alfred Kazin, I had exactly the opposite reaction. To me the jumble of signs and advertisements on busy city streets, instead of being Watkins's "clarions of commerce," looked like a verbal and visual Tower of Babel. Words and images that were intended to convey messages became meaningless when thrown together in a seemingly random manner. Their proximity suggested order, but the order was an illusion. A parking lot sign had nothing to do with an adjacent Merit

cigarette advertisement, or a sign about New York's tough gun law seen in the background. What I saw was chaos, and this for me was a symbol of the visual and verbal cacophony of the world of commerce.

In his book, Watkins presents his choice of one hundred classic advertisements, some of which dated to the nineteenth century. The primary criterion he used was the effectiveness of the message in achieving the objectives of the advertiser. There is no doubt that the headlines were memorable, and many of them still echo in our minds today:

New York scene, from *Our New York*

EASTMAN KODAK® —	"You Press the Button—We Do the Rest "
IVORY SOAP® —	"99 $^{44}/_{100}$% Pure"
CADILLAC® —	"The Penalty of Leadership"
WOODBURY SOAP® —	"The Skin You Love to Touch"
LUCKY STRIKE® —	"Reach for a Lucky Instead of a Sweet"
LADIES HOME JOURNAL® —	"Never Underestimate the Power of a Woman"

The problem with these advertisements is that visually, at least to my eye today, their designs were mundane. In fact they were so dull that if they appeared in a contemporary publication one's eye might pass them by without a second look. But Watkins was a copywriter, not an art director; he was not, apparently, concerned with how the text looked

on a page. He was focusing on concepts and clever headlines, all of which *were* quite compelling and clearly successful.

When I was attending City College in New York, I used to commute on the subway. Every day I would look at the advertisements in the subway cars and wonder why they were so "badly" designed. The elements in the advertisements seemed to be combined in an almost random manner, with no defined order, with mixed typefaces, and poor illustrations. It would be just as easy, I thought, to design them well. I wondered if the designs were poor because the advertisers didn't know any better, or whether what I considered inferior layouts produced superior results.

Watkins's book helped me understand the answer. For the creators of those subway advertisements, design excellence was not an issue. They were hired to create messages that would be noticed in the helter-skelter of the subway environment. They believed that simply producing those advertisements, even—or perhaps especially—with their ungainly layouts, was the best way to command attention. The clean, simple, striking forms that I associate with good design, that win prizes and are exhibited in museums, were irrelevant.

The same is true today in the packaging we see in supermarkets. Looking at Campbell soup cans only tells us what is in the soup—clearly and distinctly but not necessarily esthetically. (It took the imagination of Andy Warhol to show us how something so mundane could be transformed into a work of art) On the other hand, packaging intended for a theoretically sophisticated client, like nonfat cottage cheese, may feature typography that resembles an abstract painting and has a genuine design quality. Similarly, a plastic bag created for world travelers with the equivalent of "thank you" printed on it in five languages deserves a graphic design award.

Advertisements in subways can also be well designed if it suits the advertiser's purpose. Today there are posters from a single company filling the whole side of a car with striking images that make a strong visual as well as a verbal impact. For instance, New York Life's campaign on "The Company You Keep" shows a series of black and white photographs of steelworkers with such tag lines as "Strength is our steel . . . Humanity is our cornerstone . . . Integrity is our foundation." Some outstanding designs can be found in large advertisements for bus stops and on the exterior of buses. But there are still many "just-

tell-it-straight" advertisements in subways and buses in which the quality of design appears to be irrelevant. In these, passengers are just told where to find a plastic surgeon, a language school, or an over-the-counter medical product.

A pioneering effort to place well-designed posters on public transportation was a campaign called "Poetry in the Buses," started some years ago by a group of bright and imaginative people in Pittsburgh, Pennsylvania. They conceived the idea of matching striking visual images with lines of poetry, and they set up a nonprofit organization to do so. I heard about their program when the group used some of my photographs of sculpture for their posters. The idea was to encourage people to exercise their minds rather than to let them become blank. Often when we ride on buses or subways our minds are vacant, and we can see in the faces of others what T. S. Eliot described as the growing terror of nothing to think about.

Poetry on the buses—or subways—helped till those moments of emptiness with inspiration. The well-designed posters were a welcome relief from the miscellany of poorly designed advertisements that otherwise filled those spaces. Today we can see poetry in the subways of New York as part of a program called "Poetry in Motion," providing welcome moments of reflection to passengers.

A similar program was once recommended to the Outdoor Advertising Association. From time to time legislation has been proposed to limit the ugly siting of billboards on highways or in certain sections of cities. One way the billboard advertisers could defend themselves would be to use empty billboards for paintings created by

Shopping bag

local artists. This would transform the billboards into displays of works of art, making them contributions to the cultural life of the community rather than the blight that they were often said to be. As far as I know the plan was never carried out, although it could have turned sections of our highways into outdoor museums.

There is another kind of outdoor "museum" that does exist and that exhibits outstanding graphic works that most of us do not recognize as esthetic objects. That "museum" includes the carefully designed road signs that tell drivers to stop, to watch out for a curve ahead, a bump, or a slippery surface; that tell adults to hold the hands of children when crossing the street, or bicyclists where they can and cannot ride, or pedestrians where they should cross the street. These signs are part of an international system of symbols that bring a high level of design into our daily lives. If you want to see why they deserve to be called works of art, just think of what they would look like upside down. Imagined that way, the forms can be seen on their own, and often they are quite striking.

Outstanding graphics can also be found in such unlikely places as on sewer covers, lampposts, electric utility poles, gates, door knockers, and door numbers. One simply has to keep an eye out for unusual shapes and patterns, and stop for a few seconds to enjoy the product of an anonymous designer's imagination and skill. Even more impressive, but equally unappreciated, are the logotypes that have been created by outstanding designers for commercial enterprises. Most people don't realize how much thought and creative effort went into such designs as the symbol for Mobil Oil, the U.S. Postal Service, Mercedes Benz, and hundreds of other companies. In some instances such logos have been exhibited in museums.

Other artists who have contributed works in public places have painted murals on the sides of buildings. These "wall paintings" provide a welcome relief to bland and sometimes ugly sections of a city. Some are striking, abstract designs that provide visual excitement to blank walls. Others are depictions of grand landscapes that seem to liberate their viewers from the closed-in feeling of an urban setting. Still others are realistic paintings of windows with curtains and flowerpots.

Graffiti are a form of decoration that has exploded in our time, although the idea of leaving one's mark in a public place is not new. In an excavated section of the wall around the old city of Jerusalem, there

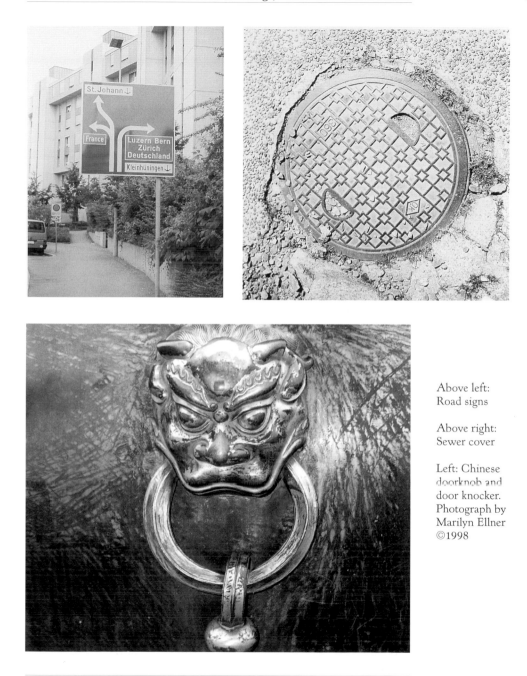

Above left:
Road signs

Above right:
Sewer cover

Left: Chinese
doorknob and
door knocker.
Photograph by
Marilyn Ellner
©1998

are marks made by crusaders well over a thousand years ago. Initials have been cut into barks of trees and written on walls of buildings for centuries. But modern graffiti are a form of serious, albeit naïve, painting by untrained artists. Often their technique is remarkably sophisticated and the results are worthy of being exhibited in a gallery. It may be that graffiti were inspired through some mysterious process by the abstract expressionist painters—Franz Kline, Jackson Pollack, Robert Motherwell, Richard Pousette-Dart. Several graffiti artists, like Jean-Michel Basquiat, Keith Haring and Kenny Scharf, were part of what became known as the graffiti movement that flourished during the 1970s. Basquiat, who died of a drug overdose at the age of twenty-seven, was the best known. The art critic Robert Hughes believed that he had "some kind of graphic zip." Arthur Danto thought he was gifted and that he had left behind a substantial body of work, and would have been a significant painter in any era.

Although the work of graffiti artists could be stimulating esthetically, it often violated the forms of objects or structures on which it appeared. In a way, that conflict seemed part of the challenge that excited these artists. Sometimes they figured ways to paint marks on virtually inaccessible areas, for example, high on abandoned buildings with no visible means of access. They seemed to be making a statement about the way things look in our society, and why they objected to that look, not infrequently with a great deal of anger.

Perhaps what graffiti fight against most strenuously are the clean lines of modern buildings and manufactured products that are popular with sophisticated customers. But popularity is not necessarily a mark of good design. I have always been curious that "good design" is what those whose judgments are most highly respected—museum curators, critics, scholars—think is good design, and I have learned from them and developed my own sensitivities as a result. Consider the difference in the way Rosenthal China and Lenox China created the patterns for their dinnerware. Years ago, I visited a Lenox plant, and was told that every year a team of artists produced a number of designs for consideration by management. These were then reviewed in focus groups by researchers to determine which ones were most likely to be popular. The final patterns were chosen on the basis of that research, and the advertising/marketing campaigns were launched to sell them to the consumer. Because they had been so carefully researched, these new

designs almost always turned out to be the most popular of all the new patterns introduced by any of the leading manufacturers each year.

Rosenthal took the opposite approach. The head of the company was committed to good design, and each year a team of artists developed patterns for him and other top executives to consider. Test marketing did not play a part in the final selection; instead management, which took good design seriously, made the decision on the basis of knowledgeable esthetic judgments. The approved patterns were then introduced to the market.

Each year Lenox outsold Rosenthal many times over, although Rosenthal's designs were widely considered by the art and design community (critics, journalists, curators, etc.) to be far superior esthetically. Recently, I related the case history of Rosenthal and Lenox at a conference at the Aspen Institute, a center for the exchange of views by leading thinkers in different fields, located in Aspen, Colorado. As it happened, one of the top executives of Rosenthal China was at the conference, and afterward he came up to me to ask whether I thought it would be possible to use the marketing know-how of Lenox to sell the fine designs of Rosenthal. It was a difficult question for me to answer. I replied that expert marketing know-how can help improve sales of any good product, but catering to public taste might always outsell educating it, no matter how effective the marketing. The Rosenthal executive was disappointed at my answer; but I admired him for his dedication to a mission of good design.

In 1956, the Art Directors' Club of New York published its first *Annual of Advertising, Editorial Art and Design* to call attention to the inherent values of outstanding graphic design. Here, for the first time, readers could look at the well-designed works and appreciate them for their esthetic qualities as well as their messages. Every year since, the club has published a volume on its awards. In 1996, on its fortieth anniversary, the gold medalists honored a Volkswagen ad with a dramatic photograph of its new model, accompanied by a headline "We've gone places!" There was a Clairol® ad with a photograph of a beautiful blond sliced into vertical sections with a headline "Up to now you could never be any of these delicate blondes." A medal was awarded to a Young & Rubicam ad with the word "tonnage" written vertically in heavy type making a dent in the horizontal type below that began, "When is a heavy weight of advertising dollars bound to succeed?"

Good design is a quality that people with an aesthetic sensitivity can enjoy as works of art. I have found, for instance, that if I don't yield to the temptations of turning down the volume of the TV set and look-ing away when the commercials come on, I can enjoy the outstanding creativity of the photography or computer graphics. That doesn't mean I rush out to buy the product, for good design does not automatically translate into sales. In fact, many believe there is little, if any, connec-tion between the two. Although this is not a theory I support, I was sad to note that the 1996 volume produced by the Art Directors' Club included a *Look* magazine ad that read, "This year the Art Directors' Club gave more awards to *Look* than to any other magazine. *Look* is grateful and very, very proud." Shortly after receiving that honor, *Look* published its final issue and went out of business!

One of the most effective promoters of good design is the American Institute of Graphic Arts, which annually selects the fifty best-designed books of the year. Many of them are books on paintings, sculptures, photography, and architecture; but there are other kinds of books as well. For instance, one year the list included an aerobics instruction manual, and books on plants, birds, dogs, clothes, furniture, a series of how-to-do-it guidebooks for the home, biographies, chil-dren's books. Also selected by the AIGA are the best-designed com-mercial publications in a variety of fields. The goal of the organization is not only to honor outstanding graphic achievements, but also to stimulate awareness of the value of good design and to motivate designers to do high-quality work.

Posters and billboards often can, on occasion, be examples of good design. This is especially true in Europe, where advertisers some-times seem more open to esthetics in their selling messages than their American counterparts.

In New York, the Museum of Modern Art regularly organizes exhibitions of contemporary outstanding decorative arts. "It has been a long-standing assumption of the modern movement," stated the intro-duction to one MOMA catalogue entitled *Italy: The New Domestic Landscape*, "that if all man's products were well designed, harmony and joy would emerge eternally triumphant." Exhibitions of a wide variety of well-designed objects including furniture, appliances, tools, china, and glass, are based on this principle.

When the Cooper-Hewitt Museum became the Smithsonian

Institution's National Museum of Design in 1976, it opened with a major exhibition called *Mantransforms.* The catalogue included a wide variety of objects, including clothing, typewriters, tools, furniture, handcuffs, and windmills. In the foreword, the director, Lisa Taylor, wrote: "There is no greater touchstone between people of different times and places than objects of daily use, regardless of their form, medium or decoration." The well-known industrial designer, George Nelson, who wrote the introduction, expressed the hope that with this opening exhibition, the museum would become "the spearhead of an international movement to bring design back to the spiritual dimension of man."

The Scandinavians are especially conscious of the value of good design, and the publication *Scandinavian Review* regularly includes articles on fine design developed in Denmark, Finland, Iceland, Norway, and Sweden. In Finland, a magazine called *Form · Function* is published, which showcases the works of that country's designers. Among my personal favorite Scandinavian designers is the architect Alvar Aalto of Finland. Some years ago, when my wife and I visited Finland, we had the pleasure of meeting Aalto's widow at her home in Helsinki. We had bought a number of her late husband's works, including a famous glass vase that seemed to be shaped in the form of a lake. Much later, I was impressed with the exhibition of Aalto's work at the Museum of Modern Art. In my view, he was one of the most original and creative minds of twentieth-century design. Another Scandinavian designer who impressed me was Henning Koppel of Denmark. When Laura and I were in Copenhagen we bought works of Koppel's that have contributed a sense of grace and elegance to our table for years. Koppel designed a wide variety of products, and for him, all of these objects were made as works of art. "It is the joy to be found in the sculptural and living forms," one critic wrote about Koppel, " which can be wrested out of the material itself that is his aim. It is not that he is against 'use' as an absolute condition For 'use' is an exciting link in the creative process."

Many other commercial objects lend themselves to good design. The landmark exhibition at the Guggenheim Museum, "The Art of the Motorcycle," in 1998 was a dramatic example. Crowds lined up around the block to see what turned out to be one of the most popular exhibitions in the museum's history. Perhaps it is because motorcycles have

Michaux
Perreaux, *Steam
Velocipede,*
France, 1868.
Exhibited at
Guggenheim
Museum, June
26–September
20, 1998. From
Musée de l'Ile
de France,
Sceaux

come to represent unleashed energy in our society that the designers
have used their skills to define lines and shapes that express great
power. As the director, Thomas Krens, wrote in his preface:

> The motorcycle is a perfect metaphor for the twentieth century
> . . . invented at the beginning of the industrial age, its evolution
> tracks the main currents of modernity. The object and its history
> represent the themes of technology, engineering, innovation,
> design, mobility, speed, rebellion, desire, freedom, love, sex, and
> death . . . For much of society, the motorcycle remains a forbidden
> indulgence, an object of fascination, fantasy and danger.

This observation, and the exhibition of a wide variety of historic
machines in a museum, changed many people's perception of what pre-
viously was thought of as a commonplace object. When those who
have seen that exhibition look at motorcycles speeding along the high-
way or lined up along the curb of a city street, they are likely to think
of all those many human characteristics they appear to express.

Null Space III,
a sculpture by
John Safer

Other commercial icons of design are elegant automobiles like the Rolls Royce, Porsche, Jaguar, Mercedes, BMW, Infinity, Lexis, each of which has a distinctive esthetic of its own. But some of the most spec-tacular forms in the world of manufactured objects can be seen in the flying machines that have become part of contemporary life. Walter Boyne, the first director of the National Air and Space Museum in Washington, D.C., published a book entitled *The Leading Edge,* in which he described the evolution of flight from the Wright Brothers' "Flyer" that was flown at Kitty Hawk, N.C., to the space shuttle. Over one hundred variations of flying machines were included in the book, with dramatic photographs of most of them. Boyne didn't refer to air-planes as works of art but the photographs he chose made the point. Later, he showed his sensitivity to the esthetic quality of such forms when he wrote the text for a book on the sculpture of his friend John Safer, and described one of his works as having "a true leading edge, a wonderful, proud arc of shining, polished steel." He believed that Safer had created sculptural works that revealed the inner beauty of flight.

CHAPTER SEVEN

Music

to the

Eye

LEONARDO DA VINCI FILLED MANY PAGES OF HIS NOTE-books with acute observations of the flight of birds, and he visualized the creation of a man-made flying machine as perhaps the ultimate human achievement. Leonardo rarely used poetic language in his scientific descriptions, but one of the few times he permitted himself to do so was in the midst of his notes about the workings of a bird's wings. He wrote: "The great bird will take its first flight upon the back of the great swan, filling the whole world with amazement and filling all records with its frame; and it will bring eternal glory to the nest where it was born."

It's not clear whether "the great bird" was the flying machine the artist envisioned, but it is clear that he thought that a bird's wings were among the most wondrous objects ever created.

I sometimes find myself thinking of a bird floating in the air as music. The extraordinary grace it shows as it moves in the air, periodically holding completely still without the slightest movement of its wings, is like a long, beautiful note from a heavenly sphere. One can be mesmerized by birds flying through space, watching them swoop up and down and around, their wings rising from perfect stillness to an

infinite variety of movements as they follow configurations in their flight. The photographer Gerald Bloch caught three such birds in his camera lens and thought he heard the song of their flight. The melody softens when the birds slow down to land and look around at their new surroundings—which may be on a sculpture, in a tree, a frozen lake, or any one of a thousand different places. It quickens when they take off again on a new flight seeking another destination. And when they fly in formation, the whole flock is perfectly synchronized, changing direction at an instant's notice as if following a conductor's baton.

Bird watchers spend hours looking for sightings of different species, and are thrilled when their search is successful, not only because of the rarity of their find, but because of its beauty. That there are so many species, each with its own colors and shapes and ways of life, is one of the miracles of creation.

The wondrous shapes of all living beings and the way they move their bodies can be magnificent to behold. What we are looking at is not fixed in time and space but is constantly changing. It may be a butterfly hovering over a flower, a squirrel performing acrobatic feats as it jumps from branch to branch, a horse trotting down a path, a cat play-

Three Birds in Flight.
Photograph by Gerald Bloch

Clouds seen
over a hill

ing with a child. When one visits a zoo, it is a treat to see monkeys
swinging from bar to bar and seals slipping in and out of their pools. In
aquariums we can see an incredible variety of exotic fishes making
their way through the waters with their own special movements.

These images can delight the eye as beautiful passages of music
excite the ear. There is a remarkable similarity between the two,
although one is created by nature and the other by the human mind.
You can even hear musical sounds as well as see visual harmonies when
the wind blows through the leaves of a tree and you watch them sway
back and forth like a symphonic movement. Perhaps *watch* is not the
right word, for when one watches something one is focusing on a sin-
gle place. For me the best way to see the symphony of leaves blowing
in the wind is to look at them without focusing my eyes on anything. I
see the whole complex across the full span of vision with the same clar-
ity, and I become aware of melodies repeating themselves as gusts of
wind produce their own combinations of movements. When a partic-
ularly strong gust comes along, a whole branch will sway in the wind,
and it is like cymbals clashing or drums beating. When the wind dies

Lavalike stones
in the sea

down, a gentle breeze may blow on one small group of leaves like the
notes of a flute, making them flutter back and forth. To use another
metaphor, seeing all the leaves at once is like watching the rhythms of
the *corps de ballet* rather than the individual movements of each dancer.

Clouds perform another kind of visual music. When one lies on
one's back and looks at the sky, one can see the clouds carried along by
the wind, constantly changing their shapes. Sometimes they give birth
to offspring, which follow their own destiny; sometimes they become
smaller and smaller until they disappear; sometimes they combine with
other clouds to fill the sky with billowing forms. There are names for
different classifications of clouds, but every formation is unique.
When one sees them from above in an airplane, sometimes so close
that it seems as if one could almost touch them, the sight is other-
worldly. The airplane moves faster than the clouds, so what the air-
borne viewer sees is not their movement but all the different shapes
they take when they seem to stand still in the sky.

Flowing water has a different kind of rhythm. When I watch the
waves of the ocean washing up on the sand, I feel that I am in touch

with elemental tides. In Virginia Woolf's masterpiece, *The Waves*, the chapters are preceded by beautiful descriptions in italics about the appearance of the sea, beginning with sunrise and ending with sunset. The book opens as day is about to break:

> *The sun had not yet risen. The sea was indistinguishable from the sky, except that the sea was slightly creased as if a cloth had wrinkles in it.*
>
> *Gradually as the sky whitened a dark line lay on the horizon dividing the sea from the sky and the grey cloth became barred with thick strokes moving, one after another, beneath the surface, following each other, pursuing each other, perpetually.*
>
> *As they neared the shore each bar rose, heaped itself, broke and swept a thin veil of white water across the sand. The wave paused, and then drew out again, sighing like a sleeper whose breath comes and goes unconsciously.*

At the end of the book the sun sinks below the horizon. This mirrors the story of the characters in the book who begin as children and end with approaching death. The last lines of the book were spoken by Bernard:

> And in me too the wave rises. It swells; it arches its back. I am aware once more of a new desire, something rising beneath me like the proud horse whose rider first spurs and then pulls him back. What enemy do we now perceive advancing against us, you whom I ride now, as we start pawing this stretch of pavement? It is death. Death is the enemy. It is death against whom I ride with my spear couched and my hair flying back like a young man's like Percival's when he galloped in India. I strike spurs into my horse. Against you I will fling myself, unvanquished and unyielding. O Death.
>
> *The waves broke over the shore.*

For Virginia Woolf her words were a tragic prophecy. She published *The Waves* in 1931 when she was forty-nine years old. Ten years later,

in the midst of a deep depression, and fearing that her breakdown would be permanent, she filled her pockets with stones and drowned herself in the river Ouse, on the southern coast of England near Lewes, Sussex.

To me, the sea seems symbolic of the storms that rage within us, while the land is symbolic of life and beauty. Albert Pinkham Ryder painted the sea as something mysterious, even foreboding. For Turner, the sea represented the elemental forces of nature. Courbet seemed to visualize the sea as the source for all living things, as when he depicted his famous mermaid rising from the green waters. In Winslow Homer's paintings, one can almost hear the crash of giant waves as they smash against the shore.

Literary references are equally dramatic. Coleridge, in *The Rime of the Ancient Mariner*, envisioned the sea as a metaphor for the human condition. After the Mariner had done a "hellish thing" and shot the Albatross, he had to pay the price:

> Down dropt the breeze, the sails dropt down,
> 'Twas sad as sad could be,
> And we did speak only to break
> The silence of the sea!
>
> All in a hot and copper sky,
> The bloody Sun, at noon,
> Right up above the mast did stand,
> No bigger than the Moon.
>
> Day after day, day after day,
> We stuck, nor breath nor motion;
> As idle as a painted ship
> Upon a painted ocean.
>
> Water, water, everywhere,
> And all the boards did shrink;
> Water, water, everywhere,
> Nor any drop to drink.
>
> The very deep did rot: O Christ!

That ever this should be!
Yea, slimy things did crawl with legs
Upon the slimy sea.

Herman Melville suggested in *Moby Dick* that "Noah's flood is not yet
subsided; two thirds of the fair world it yet covers." He referred to the
sea as "a foe to man who is an alien to it . . . No mercy, no power but
its own controls it. Panting and snorting like a mad battle steed that
has lost its rider, the masterless ocean overruns the globe." T. S. Eliot,
in *Four Quartets*, wrote about the "menace and caress of wave that
breaks on water," and among the many "sea voices" he heard was that
of the tolling bell that "Measures time not our time, rung by the unhur-
ried / Ground swell, a time / Older than the time of chronometers . . ."
One senses the measure of that time when watching waters swirling
around rocks in the sea, or making endless formations of rippling lines
as the sunlight hits the surface of a pool or creates sparkles in the bay.

Waters from all sources and in all forms seem to have the power
to evoke metaphors of human emotions. Edvard Munch incorporated
in some of his paintings a long, erect reflection of the setting sun on
water that some have described as a phallic symbol. Slashing rain pour-
ing down from above can seem like tears from a sobbing sky, especially
when it is punctuated by roaring thunder and flashing lightning.
Snowflakes floating slowly in the air may seem, by contrast, like gentle
kisses. Bubbling waters from hot springs give one the feeling that the
earth is a living being. Geysers thrusting upward are like shouts of the
earth to the sky.

I have a curious personal relationship to the sea. My father,
Jonathan Finn, was a writer, primarily of books on criminology. But in
his later years he wrote a book on Janet Roper, the head of the
Seaman's Institute in New York. Called "Mother Roper" by the seamen
who revered her, she had been married to a preacher, Harry Roper,
who was quite an eloquent and inspiring speaker. As it happens, the
book was never published because of an objection from the Roper fam-
ily after she died. But I kept a copy of the manuscript when my father
died because I thought many parts of it were quite beautiful. What I
found especially remarkable was my father's love of writing about the
ocean even though he was the only person I ever knew who feared the
water and never learned to swim!

Here is an especially eloquent passage in which my father described a sermon Harry Roper gave to a group of seamen. I suspect the words were at least as much my father's as they were Roper's.

> He spoke of his boyhood ambition to become "a deep-water sailor" on a ship that would sail "faster than the wind." He did not once mention their souls, but dwelt on the sea, now lashed to fury, chopped into short, curling waves, now lengthening into great rolling surges, each one different in form, designed by "an Architect who never repeats Himself." Its fury ceased, he said, and it lay calm and still, as if God had taken His ocean and hushed it to sleep. He asked the silent men looking up at him if they ever asked themselves where the rocks they saw along the shores got their grandeur and strength. "Was it not by the beat of a thousand waves?" The sand, he said, got its beauty by the rolling surge; the rounded pebbles by the rub and grind of a thousand storms; and he reminded his profoundly attentive audience that deep down, four fathoms and more, the wildest storms leave the sea in perfect stillness; that the heart of the ocean is always perfectly at peace. He concluded with the suggestion of a spiritual interpretation of his talk; that the storms of life, fed by uncertainty, disappointment, and disillusion, can remain surface-deep as long as the heart is sound.

My father started painting when he was in his eighties, and his dream was that one day he would be able to paint the water flowing in a running brook. He tried many times, but was never satisfied with the result. I think of him when I see water rushing over the stones in a stream and watch the remarkable shapes it takes as it eddies around them. After my father died, I painted a brook near my home as part of a series inspired by T. S. Eliot's *Four Quartets*; my painting accompanied Eliot's reference to whispers of running streams.

I remember being awestruck by the thundering power of Niagara Falls as it flowed over the top and crashed to the surface below. It is not hard to imagine why over the years there have been a few daring individuals who chose to go over the falls in a barrel, becoming part of the force itself as they plummeted to the waters below. I remember the falls in Yellowstone Park being higher, narrower, and more poetic. And

I remember being startled when I came across the falls in Patterson, New Jersey—such a mighty thrust yet located in the middle of the city.

I find that the relationship between water and ancient rocks is especially evocative. Cliffs at the edge of the sea have ridges, crevasses, and striations that look as if they could tell the story of the passage of time since the moment of creation. The still waters of a lake with reflections of rocky mountains in the distance, seem ageless, as if nothing ever changes in the course of time.

My son Peter and my grandson Noah have gone with me on several photographic excursions in the Catskill Mountains for a book we are working on together. Once another grandson, Matthew, joined us, bringing his camera. Rocky formations around waterfalls and creeks were especially fascinating to us. Peter was our guide, while the rest of us climbed over and around the giant boulders we came across. Matthew got a good shot of rapidly flowing water on a stream coming down the mountains, and pouring over a rocky promontory. His sharp eye also made a striking composition out of shaped pipes that looked

126

like a retaining wall for a pile of rocks at the water's edge.

Athletes are a delight to watch; there is real music in the forms and motions of an ideal human body, which is why viewing the Olympics on television is such a pleasure. We watch not only to see who wins the medals, but also to enjoy the grace of champions whose bodies are capable of marvelous movements. I have the same feeling when I watch a tennis match, with players stretching, reaching, straining as they miraculously hit the ball from seemingly impossible angles and cover the court with such agility. There are equally thrilling movements in vitually all sports activities.

In ancient Greece, when athletes in the games competed nude the human body could be seen in all its glory. In modern society public displays of nudity are rare, but in our private lives we still see the naked human body as perhaps the most beautiful of all sights. There is music not only in the rhythm of bodily movements, but in every part of the human anatomy, literally from head to toe. William Blake once said "Art can never exist without naked beauty displayed," and John Donne wrote ecstatically about how a lover's hands follow his eye, caressing the body of his beloved: "License my roving hands, and let them go / Behind, before, above, between, below."

Many poets have created memorable phrases to describe the beauty of a woman's nakedness: "All her body pasture to my eyes," wrote A. C. Swinburne, echoing Edmund Spenser's "All her body like a palace fayre." John Milton revelled in Eve's "naked majesty" and wrote glowingly about her "Heavenly form / Angelic, but more soft." Edmund Spenser likened a woman's breast to "a bowl of cream uncrudded," while D. G. Rosetti thought her breast had "heavenly sheen," and John Keats described it as being "warm, white, lucent, million-pleasured."

The Greeks tended for the most part to celebrate the male body as the ideal, while the poets and artists of recent times have tended to celebrate the female. Often painters of the female nude have placed their subject in an environment that seems to bring out the special beauty of her figure.

One relatively little known master of the nude is the Swedish artist Anders Zorn. My wife and I have a collection of his etchings, which we think are wonderful expressions of a healthy and robust love of the female figure. Many of these etchings show women who look as if they have taken time off from work in the afternoon to take a dip in

Photograph of
Barbara
Antonelli by
Maurizio
Ghiglia

the sea. Others are in home settings.

The beauty of a naked woman in familiar surroundings is also a favorite subject of the photographer Maurizio Ghiglia. He and the painter Barbara Antonelli have lived together in a small apartment in Florence for many years. Barbara, who used to work as an architectural draftsman, has a talent for making the most of limited living spaces; her brilliant design of their $2^1/_2$-room apartment is an architectural gem. Although Maurizio's commercial specialty is photographing for the

Painting by
Barbara
Antonelli of the
photograph

theater, his passion is photographing Barbara. Often his photographs
of her become models for paintings by her of herself in the nude. One
such photograph that I found particularly lovely showed Barbara in
their handsomely designed bedroom; I thought it a perfect expression
of their life together.

In a different kind of imaginative venture in photographing the
female nude, Gerald Bloch has turned his camera on the anonymous,
unassuming women one sees everywhere in the course of daily life. He

Nude.
Photograph by
Gerald Bloch

has made a point of not using models, but rather, in his soft-spoken and disarming manner, of inviting waitresses, salesgirls, housekeepers, and individual acquaintances to pose for his remarkably sensitive pictures. The results of the unique rapport he establishes with his subjects by

means of insight and empathy, yield images that are at once lyrical and sculptural.

Drawings of the female nude, like photographs, can have a rare freshness. In my opinion, the nineteenth and early twentieth centuries were a period when drawings of female nudes were especially sensuous. Some of the most marvelous drawings of this subject ever made were by Jean-Auguste Ingres and Pierre-Paul Prud'hon. Both had a seemingly magical touch that enabled them to capture the lines and shapes of a woman's body. Henri Matisse's drawings of the nude are beautiful, but quite different; for him the vision of a woman's body gave him the opportunity to make beautiful lines. Some of Gustav Klimt's nudes are ravishing; often a part of the body is covered by a sheet or a garment, which makes the woman's nakedness seem like a revelation. Burne-Jones, Fantin Latour, Renoir, Rodin—all produced exquisite drawings of the female nude.

Birds, clouds, nudes—all these make their own kind of music for the eye. But most of us know little about their visual structure, the scales, as it were, that provide the framework for their music. In 1975, a French mathematician published a book on what he called *fractals* to describe structures in nature that are created by a new geometry of "iterations" and "self-similarities." Then in 1991 the physicist, Michael McGuire, published *An Eye for Fractals* with his own photographs of fractals, which Mandlebrot called "a feast for the eye." These fractals seem both beautiful and mysterious to laymen like me, but according to McGuire they are "based on a geometry that transcends the points, lines, and places of Euclid to grasp and describe the shapes of trees and mountains and clouds. Complexity and simplicity are complementary parts of its whole." One begins to understand what he means when looking at both his abstract diagrams of forms endlessly repeating themselves and his fine photographs of fruits, branches, sand formations in deserts, and cliffs overlooking canyons.

I wonder if someday someone will discover how to analyze "phosphenes" the way Mandlebrot and McGuire have analyzed fractals. "Phosphenes" are the forms one sometimes sees when we close our eyes and look for patterns of lights that seem to move across our field of vision. They are designs not dissimilar to what McGuire showed in his diagrams and photographs. We can conjure up phosphenes by closing our eyes and searching for something to look at,

and when we are successful, what we see can be endlessly fascinating.

In today's world we are constantly being exposed to new kinds of artificially created images on our television and computer screens. We come to think of them as real because we see them so often. In that respect they are reminiscent of Plato's shadows on the wall. In *The Republic*, he described a hypothetical group of prisoners in a cave whose heads and legs had been chained since childhood so that they could only see shadows on the wall. Plato pointed out that if they were to be released and permitted to turn around and see the real objects that were casting the shadows, they would not believe the real objects were real. They would be convinced that the shadows were the only true reality, since they were all the prisoners had seen for so long.

But we are not chained to a wall and can see both the "real" objects in our lives and the "unreal" objects on television and comput- er screens. Children who grow up looking at television commercials that show cars driving off into space, or tiny people standing on the edge of a bowl of cereal are not confused about reality. These images are as common as those they see when they are sitting in their parents' car or eating their breakfast food. Their experience of reality is there- fore constantly being expanded by adding new kinds of images created by human ingenuity. These images enable them to glimpse "truths" that were never seen or imagined before. As a result, all of us are becoming used to living in both worldly and otherworldly environments.

In a curious way *shadows* help us understand the interaction between these environments. I remember as a child watching shadows moving across the ceiling of my bedroom at night as cars moved along the street. At the time they seemed ominous and frightened me. Somehow they represented the world of fantasy intruding into the inti- macy and privacy of my bedroom. I didn't know why they made me afraid, but I kept my eyes open for what seemed like hours watching them. Perhaps I sensed they were signals from a supernatural world I didn't understand. That was when I first experienced the power of shadows to evoke images of another reality.

As I grew older I began to think with Peter Pan that shadows somehow contain the essence of our souls. When for a short time Peter Pan lost his shadow he was devastated. We are not in danger of losing our shadows, but we do attach importance to having them.

We are all shadowless on a gray day. But when there is a thick fog,

as often happens in London, there is a different kind of mystery. It is as if one big shadow envelops the world. Cars have their headlights on in the middle of the day, branches of trees disappear in the mist, and it seems as if the world of reality is about to vanish altogether in a sea of gray nothingness. It is difficult to maneuver in a thick fog but endlessly fascinating to watch.

Today I am fascinated by shadows on mountains, on sides of buildings, on faces of people. They somehow bring out the essence of reality by creating an awareness of depth and dimension. They seem like musical compositions accenting the contours of the visible world. Most of us don't bother to look at shadows; we are more conscious of the objects from which they are cast. But if we recognize shadows as part of reality, as when we see a composition of an iron chair on a porch, we can discover a masterpiece of nature. In London's National Gallery, there is a painting entitled "A Man Seated Reading at a Table in a Lofty Room," which is said to have been painted by a follower of Rembrandt. It is in effect a representation of the shadow cast by a window with a decorative iron grating. The complex shadow suggests the world outside that one can almost hear but cannot see. The twentieth-century painter Giorgio de Chirico created enigmatic scenes with long shadows that look as if they were stretching to the end of time. Edward Hopper opened our eyes to the different ways shadows affect our moods during the course of a day, from early morning to late afternoon, and even at night under artificial light. Ad Reinhardt's black paintings showed us what the world is like when all is in shadow.

Shadows are the stuff of which striking images are made. One friend of mine, Adrianne Snelling, took a lovely photograph of winter trees casting shadows and used it as a holiday card. I sometimes think that my own shadow tells me more about myself than my image in a mirror; the former is part of myself while the latter is a flat piece of painted glass that usually lies!

Shadows seem to bring us into visual contact with transcendent realities. This is a strange phenomenon, for shadows are the most transient aspect of the world around us and logically we should associate them with the most ephemeral experiences. But instead, they connect us to the world of imagination, for when we look at shadows we are not focusing on the objects to which they belong, but the forms they create themselves. And they seem to have the quality of an enduring

Right: Shadow of an iron chair

Opposite: *Winter Scene at Estrellita— Liggie's Gazebo.* Photograph by Adrienne Snelling

reality. The shadow on a terrace on the Greek island of Santorini, in a photograph taken by Susan Slack, creates a striking base for a magnificent view of the sea and the hills on the distant shore. The image it creates seems timeless. We are looking at the forces of creation. Everything that exists may be present only for an instant, like a shadow, but that instant is part of an ultimate reality.

Perceiving such an ultimate reality is the primary goal of William Blake's prophetic works. He felt that mankind had been blinded by the picture of nature described by Bacon, Newton, Locke, and their heirs. He warned that their teachings had hardened our optic nerves into opaque bones and that as a result we were perceiving the world around us as a "black pebble." To open our eyes to the deeper truths of existence, Blake urged us to see ourselves "like the diamond which, tho' cloth'd / In rugged covering in the mine, is open all within, / And in [our] hallow'd center holds the heavens of bright eternity."

Blake's prophetic works are in the tradition of the Old Testament. He wanted people to look beyond the physical world into the world of imagination, "to see eternity in a grain of sand." The poet Algernon Charles Swinburne, was in awe of Blake's ability to pierce "the veil of outer things":

To him the veil of outer things seemed always to tremble with some breath behind it: it seemed at times to be rent asunder with clamor and sudden lightning. All the void of earth and air seemed to quiver with the passage of sentient wings and palpitate under the pressure of conscious feet. Flowers and weeds, stars and stones, spoke with articulate lips and gazed with living eyes.

Blake invented his own mythology to enable him to articulate his views. The names he chose for different forces make his works difficult to read, for one has to try to remember what they stand for. *Albion* stands for the eternal man; *Urizen* for reason; *Tharmas* for instinct; *Urthona* for the imagination; *Luvah* for passion; *Golgonooza* for works of art; the *Four Zoas* for the eternal and archetypal faculties of Man; *Allamanda* for communication, learning, and the exchange of ideas; *Bowlahoola* for the energizing blood of the body; *Beulah* for love, pity, and sweet compassion; *Udan-Adan* for space; *Enturthon Benython* for a world with an empty core; *Ulra* for chaos; *Rintrah* for a reprobate. Other names in his pantheon of gods are *Vala, Tirzah, Ololon, Los, Enitharmon, Elynittria, Rahab, Leutha, Palamabron, Orc.* He also uses traditional names like *Satan, Milton, Jerusalem, Eden, Jesus, God,* but gives them his special meaning. It would be helpful to read Blake with a glossary of names by one's side!

Opposite: *Shadow on a Terrace, Santorini, Greece.* Photograph by Susan Joy Slack

A central message of Blake's writings and images is that we must learn to look at the outer world with the inner eye of imagination. He was fascinated by the eye as an organ and created a series of engravings of the anatomy and physiology of the eye for a book entitled *Rees Cyclopaedia.* In an essay on his work, the writers Kay Parkhurst and Roger R. Easson, stated Blake's belief that if we only use our eye to look at the outside world as it sees it without calling on the soul's imaginative powers, what we see is limited and flawed. "If as Blake assumes, at its center the universe has an eternal, infinite and immortal reality," they asked, "then how can a limited, finite and mortal observer who refuses to acknowledge that center, know the state of true existence?"

Ultimately, what Blake saw with his eyes and his soul's imagination was a vision of true happiness. He ends his great poem *Milton,* a dreamlike mythology, with the most vivid images of a world that only he could see, heralded by the immortal sound of four trumpets that

only he could hear. Its triumphant notes have the extraordinary power found in such musical passages as the choral movement of Beethoven's *Ninth Symphony*:

> And I beheld the Twenty-four Cities of Albion
> Arise upon their Thrones to Judge the Nations of the Earth,
> And the Immortal Four in whom the Twenty-four appear Four-
> fold
> Arose around Albion's body. Jesus wept & walked forth
> From Felpham's Vale clothed in Clouds of blood, to enter into

> Albion's Bosom, the bosom of death, & the Four surrounded him
> In the Column of Fire in Felpham's Vale; then to their mouths the
> Four
> Applied their Four Trumpets & then sounded to the Four winds.

> Terror struck in the Vale, I stood at that immortal sound,
> My bones trembled. I fell outstetch'd upon the path
> A moment, & my Soul return'd into its mortal state,
> To Resurrection & Judgment in the Vegetable Body,
> And my sweet Shadow of Delight stood trembling by my side.

> Immediately the Lark mounted with a loud trill from Felpham's
> Vale,
> And the Wild Thyme from Wimbleton's green & impurpled Hills,
> And Los & Enitharmon rose over the hills of Surrey.
> Their clouds roll over London with a south wind; soft Oothoon
> Pants in the Vales of Lambeth, weeping o'er her Human Harvest.
> Los listens to the City of the Poor Man, his Cloud
> Over London in volume terrific, low bended in anger.

> Rimtrah & Palamabron view the Human Harvest beneath.
> Their Wine-presses & Barns stand open; the Ovens are prepar'd;
> The Waggons ready; terrific Lions and Tygers sport & play.
> All Animals upon the Earh are prepar'd in all their strength.
> *
> To go forth to the Great Harvest & Vintage of the Nation.

William Blake was one of the rare examples in the history of creative expression who was both a great artist and a great poet. He was also a great calligrapher, for the words were written in his own beautiful handwriting (although he had to learn to write backward in his etchings). It is amazing to realize that he was almost totally unrecognized in his own lifetime. He lived modestly with his wife, earning his livelihood mostly by doing engravings for other artists and poets.

Blake's masterpieces need to be looked at and read at the same time to be fully appreciated, for he combined visual and verbal images to convey his messages. The last plate of *Milton*, for instance, shows an angel or goddess, unclothed, her beautiful body in full glory, her arms upraised, her hair and robe flowing behind her. She looks up at the words written at the top: "To go forth to the Great Harvest & Vintage of the Nation." On each side stands a nude male figure wrapped in (or growing out of) a tall stalk representing harvest. Both look at the angelic figure in the center. A gentle blue sky can be seen behind the triumphant female figure. A light tint of pink is on her limbs. Darker flesh tones are washed over the two male figures and the plants surrounding them. The grass is green below.

What Blake seems to be saying with his words and images is: "If you want to see the world in all its glory, if you want to look at EVERYTHING as it should be looked at—with the heart and soul and mind, with love and imaginatio—then look at and read what I have created."

You may not find looking at and reading Blake easy to do. But if you make the effort, you will be well rewarded. There is no bolder and more imaginative way to open your eyes to the fullness of God's creation.

Index

Credits

QUOTATION CREDITS

Grateful acknowledgment is made to the following authors and publishers for permission to reproduce the quotations on the pages noted below.

p. 7: "For the Conjunction of Two Planets," copyright © 1993, 1951 by Adrienne Rich, from *Collected Early Poems: 1950–1970*, by Adrienne Rich. Reprinted by permission of the author and W. W. Norton & Company, Inc.

p. 10: Lines by William Butler Yeats quoted from "Byzantium," from *The Collected Poems of Yeats*, The Macmillan Company, 1933, 243–44.

p. 13: "Paul Strand," *Aperture*, Spring 1994, 135.

p. 14: John Keats, from *The Selected Poems of Keats* (Paul de Man ed.), Signet Classics, 1966, 93.

pp. 15–16: Jack D. Flam, *Matisse on Art*, Phaidon, 1973.

p. 18: Fyodor Dostoevsky, *Crime and Punishment*, translated by Constance Garnett, Bantam Classics, 1984.

p. 27: Donald Hall, "Weeds and Peonies," 1995–56, unpublished.

pp. 29-30: Sir James George Frazer, *The Golden Bough*, The Macmillan Company, 1933.

pp. 30–31: D. H. Lawrence, *Quetzalcoatl* (Laurence Pollinger Ltd., London; Louis L. Marz, ed.), New Directions Publishing Company, 1998.

p. 33: Albert Goldbarth, from *Heaven and Earth, A Cosmology* © 1991 by Albert Goldbarth. Published by the University of Georgia Press, Athens, Georgia. All rights reserved.

p. 36: "The Light Fantastic" (op-ed page article, October 6, 1998), by Charles R. Eisendrath, Copyright © 1998 by The New York Times Company. Reprinted by permission.

p. 37: *The Divine Comedy of Dante Alighieri*, III, *Paradiso*, translated by Lawrence Grant White, Canto XXIII, Pantheon Books, New York, 1948.

pp. 37–38: Max Dvorak, *Idealism and Materialism in Gothic Art* (translated by Randolf J. Klawiter), University of Notre Dame Press, 1967.

p. 39: William Butler Yeats, from *The Collected Poems of W. B. Yeats*, The Macmillan Company, NY, 1956.

p. 55: Excerpt from *The People, Yes* by Carl Sandburg, copyright 1936 by Harcourt, Inc., 1936, and renewed 1964 by Carl Sandburg, reprinted by permission of the publisher.

pp. 56–57: Reproduced from *Athena's Disguises* by Susan Ford Wiltshire. © 1998 Susan Ford Wiltshire. Used by permission of Westminster John Knox Press.

p. 59: John Millington Synge, *The Complete Works of John Millington Synge*, Random House, 1935).

p. 59 : William Butler Yeats, *The Collected Poems of Yeats*, The Macmillan Company, 1956.

pp. 65–66: Pablo Neruda, "The Heights of Macchu Picchu." Farrar, Straus and Giroux, 1998.

p. 66: Richard A. Turner, *The Vision of Landscape in Renaissance Italy* . Princeton Management Associates, 1984.

p. 74: *The Divine Comedy of Dante Alighieri*, III, *Paradiso*, translated by Lawrence Grant White, Canto XXX, Pantheon Books, New York, 1948.

pp. 74–75: William Morris, *The Water of Wondrous Isles*, George Prior Publishers, London, 1979.

pp. 75–76: Thomas Wolfe, *Look Homeward, Angel: A Story of Buried Life*, Scribner Classics, July 1997 (reprint edition).

p. 76: Rachel Carson, *Silent Spring*, Houghton Mifflin Company, 1994.

p. 77: *Selected Poems and Letters by Emily Dickinson*. Edited by Robert N. Linscott. Doubleday Anchor Books, 1959, 159.

p. 88: Vincent Scully, Jr., *Louis I. Kahn*, George Braziller, New York, 1962.

p. 89: Tom Wolfe, *From Bauhaus to Our House*, Farrar, Straus & Giroux, Inc., 1981.

pp. 99–101: Pablo Neruda, from *Odes to Common Things*. Copyright © 1994 by Pablo Neruda and Pablo Neruda Fundacion (*Odes* in Spanish); compilation and illustrations © by Ferris Cook; *Odes* (English translation) © by Ken Krabbenhoft. By permission of Little, Brown and Company, Inc.

p. 104: Marshall McLuhan, *Understanding Media: The Extension of Man*, McGraw-Hill Book Company, 1964.

p. 106: Julian I. Watkins, *One Hundred Greatest Advertisements*, Dover Publications, 1959.

p. 115: H. Hollein, *Mantransforms: Aspects of Design*, The Smithsonian Institution's National Museum of Design, 1976.

p. 116: Matthew Drutt and Thomas Krens, editors, *The Art of the Motorcycle*, The Guggenheim Museum/Harry N. Abrams, Inc., 1998.

p. 122: Excerpt from *The Waves* by Virginia Woolf, copyright 1931 by Harcourt, Inc., and renewed 1959 by Leonard Woolf. Reprinted by permission of the publisher.

p. 131: "An Eye for Fractals: A Graphic and Photographic Essay," by Michael McGuire; Benoit B. Mandelbrot (designer), Perseus Press, 1991.

PHOTOGRAPH CREDITS

The photographs illustrating *How to Look at Everything* are the work of David Finn, unless otherwise noted in their captions. Permission to publish these illustrations has been graciously granted by the photographers.